THE SPORT SCULPTURE OF R·TAIT McKENZIE

Second Edition

Andrew J. Kozar, PhD
University of Tennessee, Knoxville

Human Kinetics Books
Champaign, Illinois

Library of Congress Cataloging-in-Publication Data

Kozar, Andrew J.
 The sport sculpture of R. Tait McKenzie / Andrew J. Kozar. -- 2nd
ed.
 p. cm.
 Rev. ed. of : R. Tait McKenzie, the sculptor of athletes. [1975].
 Includes bibliographical references and index.
 ISBN 0-87322-336-5 (hard cover)
 1. McKenzie, R. Tait (Robert Tait), 1867-1938--Criticism and
interpretation. 2. Athletes in art. I. McKenzie, R. Tait (Robert
Tait). 1867-1938. II. Kozar, Andrew J. R. Tait McKenzie, the
sculptor of athletes. III. Title.
NB237 .M277K69 1992
730′ .92--dc20 91-33632
 CIP

ISBN: 0-87322-336-5

Acquisitions Editor: Rick Frey, PhD
Developmental Editor: Sue Mauck
Assistant Editors: Laura Bofinger and Dawn Levy
Proofreader: Karin Leszczynski
Indexer: Barbara Cohen
Production Director: Ernie Noa
Typesetter: Kathy Boudreau-Fuoss
Text Design: Keith Blomberg
Text Layout: Tara Welsch
Cover Design: Jack Davis
Front Cover Photo: Bob Golding
Back Cover Photo: 1936 Maurice Morlarsky painting of McKenzie
Printer: Braun-Brumfield
Printer for Dust Jacket and Four-Color Insert: Original Smith

Printed in the United States of America

10 9 8 7 6 5 4 3 2 1

Human Kinetics Books
A Division of Human Kinetics Publishers, Inc.
Box 5076, Champaign, IL 61825-5076
1-800-747-4457

Canada Office:
Human Kinetics Publishers, Inc.
P.O. Box 2503, Windsor, ON N8Y 4S2
1-800-465-7301 (in Canada only)

UK Office:
Human Kinetics Publishers (UK) Ltd.
P.O. Box 18
Rawdon, Leeds LS19 6TG
England
(0532) 504211

For Marian, Mary Anne, Amy, and A.J.

Photograph
Acknowledgments

Bob Golding, Philadelphia: 2, VI, VII, VIII, IX, X, XI, XII, XIII, XIV, XV, XVI, XVII, XVIII, XIX, XX, XXI

Richard Montoye, Ann Arbor, Michigan: 3, 4, 5, 9, 10, 12, 13, 14, 17, 21,25, 29, 30, 31, 33, 34, 37, 42, 47, 48, 53, 54, 56, 58, 59, 60, 62, 63, 65, 66, 67, 68, 69, 85, 86, 90, 91, 94, 95, 96, 97, 103, 105, 106, 108, 109, 118, 120, 122, 123, 125, 126

University of Pennsylvania or (McKenzie Papers) Archives: I, II, IV, V, 8, 15, 24, 28, 36, 43, 46, 52, 55, 57, 61, 64, 76, 83, 84, 87, 88, 89, 100, 101, 104, 107, 110, 111, 112, 113, 114, 116, 117, 119, 121, 124

Earl Walker, University of Tennessee, Knoxville: 6, 7, 11, 16, 22, 26, 27, 32, 38, 39, 73, 74, 77, 78, 79, 80, 81, 82

Guy Taylor, University of Tennessee, Knoxville: 19, 20, 50, 51, 70, 92, 93

Christopher Hussey, *Tait McKenzie: Sculptor of Youth*, **Century Life Ltd**: 40, 44, 45, 72, 75, 98, 99

Frank Ross, Ocean City, New Jersey: III, 18, 23, 49, 71, 102

Wayne Farrar, Niagara Falls, Ontario, Canada: 41

Joe Brown, Princeton University: 115

H.O. Crisler, University of Michigan: 35

Major James Ley, Almonte, Ontario, Canada: 1

Contents

Foreword

When Robert Tait McKenzie arrived in Philadelphia early in the twentieth century, the American sculptural school, seasoned by a century of development, had come of age. An austere neoclassicism, strongly influenced by Italy, had been gradually superseded after the Civil War by an emerging realism coupled with a new flexibility influenced by the French. Augustus Saint-Gaudens was probably our first sculptor of note able to turn this looser, realistic approach to the advantage of his American temperament; he was followed by Daniel Chester French and others in the next generation.

Paralleling the waves of foreign impact, there was also an independent, native strain which developed out of a folk-art tradition practiced by carvers of tombstones, ships' figureheads, and architectural decorations. Lack of academic training offered no detriments to the ambitious efforts of the Skillens in Boston and William Rush of Philadelphia, or to a number of later native artists who continued to work in this vein.

With his interest in sculpture and his emphasis on the study and depiction of the human figure, R. Tait McKenzie's move from Canada to Philadelphia in 1904 was a most fortunate one. Since colonial times, this city had enjoyed a favored position in the development of the arts in America, particularly under the aegis of the Pennsylvania Academy of the Fine Arts and Thomas Eakins and his pupils. At least four of the famous Ashcan School of 1908 studied there, including their leader, Robert Henri, along with George Luks, Everett Shin, William Glackens, and John Sloan.

McKenzie undoubtedly was drawn to a tradition of emphasis on the human figure established in that city a century earlier with the exhibition of Wertmuller's painting of *Danae*, followed by the mixed reactions to Vanderlyn's *Ariadne* and William Rush's approach in the sculpturing of his *Nymph* personifying the Schuylkill River. Raphaelle Peale's *After the Bath* of 1823 may well have figured in a dispute which had hardly abated some sixty years later when Philadelphia's greatest artist, Thomas Eakins, found himself embroiled in a controversy over the use of nude models in his life-classes—a controversy leading ultimately to his resignation from the Pennsylvania Academy. Eakins' two well-known medical paintings, *The Gross Clinic* and *The Agnew Clinic* (the latter completed in 1885 for the University of Pennsylvania Hospital) must have been familiar to McKenzie; it would also seem plausible to suggest that the young Canadian artist would have been cognizant of some of Eakins' sporting paintings—the early rowing series, for example, or the later studies of boxers—and possibly the photographs taken by Eakins and Eadweard Muybridge of figures in motion. Using a device called a Marey wheel, Eakins made five motion photographs in 1884, including one of a pole-vaulter in action. A print

of this subject, entitled *History of a Jump,* was exhibited at the Pennsylvania Academy in 1886. Muybridge, the famous photographer who specialized in motion photographs, was at that time involved with his experimental work at the University of Pennsylvania; at the bottom of the print he added technical details which indicated that Eakins had made the photograph at the University.[1]

Eakins also had a strong interest in sculpture throughout his life. In addition to a number of studies in clay, some of which were cast into bronze, he did at least seven commissioned works, including the life-size horses for the Memorial Arch equestrian figures of Lincoln and Grant in Brooklyn, and two of the Trenton battle monument reliefs, and he assisted his pupil, the sculptor Samuel Murray, with ten large terra cotta figures of prophets originally placed on the exterior of the Witherspoon building in Philadelphia. It has been pointed out that Eakins' models, "which he used as studies for his paintings and reliefs, and his anatomical drawings and casts, reveal a preoccupation with the correct expression of movement in human and animal forms as well as with the accurate description of these forms,"[2] an approach which would certainly be compatible with that of McKenzie. Eakins lived in Philadelphia until his death in 1916, following an independent, personal life-style within a close circle of friends, family, and followers. McKenzie, who came to Philadelphia twelve years before Eakins' death, moved in similar artistic and academic circles. Whether there was any direct contact between Eakins and McKenzie is not known, but it appears reasonable to assume at least that some of Eakins' studies of the human figure would have been familiar to the Canadian sculptor. Clearly, Eakins had helped to establish a favorable climate in Philadelphia and at the University of Pennsylvania for scientific and artistic study of the human figure before McKenzie's appearance. As well, the rising interest in the University's increasingly prominent athletic program fitted exactly the major motif of the young artist.

Sources of an artist's motivation, training, and stylistic development are sometimes difficult to ascertain, interwoven as they are within the complex web of each individual's experiences. From some known facts, and from inferences, a pattern may emerge which can prove valuable in attempting to assess the artist's direction, development, and attainment.

Like Eakins, McKenzie gravitated toward an early love of the outdoors and sports, two enduring elements which provided continual inspiration to his pursuit of a career both in the arts and in physical education. It was probably at McGill University, while earning his medical degree in the

[1]See Gordon Hendricks, *Thomas Eakins: His Photographic Works* (Philadelphia, 1969), 52. Also, Robert Taft, in Eadweard Muybridge, *The Human Figure in Motion* (New York, 1955), x. Muybridge had completed his experimental work in California with Leland Stanford and "received the news late in 1883 that the University of Pennsylvania was willing to underwrite an ambitious new program of photographic research on animals in motion and, in particular, on human motion. Elaborate equipment was provided by the university. . . ." A supervisory commission was set up consisting largely of university staff members in medicine and fine arts, and including Thomas Eakins, who was still associated with the Pennsylvania Academy. Some 100,000 photographs were made in 1884-85. A selection of these was prepared for publication in 1887, but the high cost of reproduction kept sales low. Muybridge later published two volumes containing portions of the original work: *Animals in Motion* (1899) and *The Human Figure in Motion* (1901).

[2]Moussa M. Domit, *The Sculpture of Thomas Eakins* (Washington, D.C., 1969), 5.

1880s, that he became interested seriously in art, developing enough proficiency in painting to have three of his pictures exhibited in Montreal in 1899. Although the direction of his art soon shifted toward sculpture, he continued to work in painting and related media—in this book Dr. Kozar points out that only three days before his death on April 25, 1938, McKenzie was experimenting with pastels. A study of the artist's efforts in areas other than sculpture might prove of value, not only in determining his ability in these categories, but also in providing added appreciation of his sculptural accomplishments.

R. Tait McKenzie mentioned in an unfinished manuscript that his first attempts in sculpture were aided by his friend, the Canadian sculptor George W. Hill (1861-1934). Hill, the son of a Quebec marble dealer, studied at the École des Beaux Arts in Paris under Falguière, Chapu, and Jean-Paul Laurens, acquiring the sound academic approach reflected in his *D'Arcy McGee Monument* at Ottawa and the *Strathcona Monument* in Dominion Square, Montreal. His professionalism doubtless was of some assistance to his younger friend, and the two exhibited occasionally in Montreal after 1900.

Another important early influence on McKenzie's sculptural development evolved from a prolific Canadian artist who emerged first from the strong, native, religious folk-art tradition, Louis Philippe Hébert (1850-1917). Similar in some respects to its American counterpart, this art form concentrated on wood carving as exemplified particularly in the notable work of Louis Quévillon. After a checkered early life which included farming, military service in Italy, and clerking in a country store, Hébert turned to sculpture and achieved his first recognition by winning a prize for wood carving in Montreal. He then studied in Paris, where he developed skills in other sculptural methods and was exposed to the traditional academic formula, about which he maintained certain reservations. It was said that "although he successfully invaded the classic realm, he never cared to go outside his own country for subject matter."[3] Upon his return to Canada, Hébert was soon accorded national ranking; he spent the remainder of his busy life producing some fifty important commissions, mainly in bronze, along with a number of statuettes and religious decorations. Perhaps his chief work is the heroic *Maisonneuve Monument* in the Place d'Armes, opposite the Church of Notre Dame in Montreal, which depicts the founder of that city in a historic gesture of discovery, with appropriate flanking figures and reliefs on the stone base. The synthesis of local realism with the more impersonal beaux arts monumental style developed by Hébert was probably remembered by McKenzie when he did his *Youthful Franklin* (see Plate III) for the University of Pennsylvania and his later World War I memorials.

The inspiration and guidance of Hill and Hébert may well have prompted the young artist to make his study trip to Europe in 1904. An added reason, understandably, was his wish to see firsthand the exhibition of his *Athlete* statuette (Pl. VIII), which was included in the Royal Academy of Arts exhibit in London that year, an event which gives some indication of the growing regard for his work.

[3]Newton MacTavish, *The Fine Arts in Canada* (Toronto, 1925), 86.

In London he was particularly impressed by the sculpture of John Mac-allan Swan (1847-1910) and George Frederick Watts (1817-1904). Both English artists were considered important painters as well as sculptors, and both were products of French training, having studied under the famous animal sculptor Emmanuel Frémiet, and having been influenced by a pictorialism ultimately derived from Rodin and his circle. The tense, muscular treatment of the horse and rider of Watt's *Physical Energy* (Kensington Gardens, London), with its imaginative virility and power, impressed McKenzie. He also made personal contact with Swan, who apparently gave him some technical advice. Swan was recognized as the preeminent English sculptor of animals. His human figure depiction inclined toward classical themes conveyed in a pleasing, idealistic, personal manner. His works were frequently included in the Royal Academy exhibitions, and his sculpture and paintings won a number of awards.

The year 1904 was an important one for McKenzie in other ways because it was then that he accepted an offer to become director of physical education at the University of Pennsylvania, a post which provided an outlet for his dedication to the physical education discipline and a modus operandi for continuing his artistic efforts. That summer he worked in Paris and felt more assured of his progress in sculpture, despite the rather disconcerting experience of inopportunely visiting Rodin when the French master was busily engaged with his pupils. Nonetheless, while he was in Paris, McKenzie was accepted within a circle of artists and friends who included the American sculptors Paul Bartlett and Andrew O'Connor.

Robert Tait McKenzie's sculptural style was based on an acutely perceptive fidelity to nature, effectively combined with an idealism strongly influenced by his love of classical art. His thematic range was narrower than that of many artists, concentrating primarily on the depiction of the trained athlete in action or in a pose near the climactic moment of the particular event. Like Michelangelo, McKenzie focused on the youthful male figure, usually rendered nude, as the epitome of his human figure expression. It was not until late in his career, in the *New York Skaters Club* medals of 1936 (see Nos. 109-13) and his sketch of a *Girl Discobolus* (No. 118), that the female form appeared in his athletic subjects.

Based upon both his medical degree and his professional experience in the field of physical education, McKenzie's knowledge of the human figure was considerably wider and more intensive than usually required for artistic training in anatomy. In this respect, he takes his place with Dr. Horatio Stone and Dr. William Rimmer, two earlier American sculptors who also held medical degrees. Rimmer, in particular, was a zealous advocate of correct anatomical knowledge; his *Art Anatomy* (Boston: Little, Brown, 1877), considered by some to be one of the finest American books on this subject, may well have been known to the Canadian sculptor.

Some measure of R. Tait McKenzie's significance and expertise in athletics and art is evidenced by the selection of five of his works to illustrate various field events in the monumental *Pageant of America* series published in 1929,[4] the same year that he did a number of *ICAA* medals (Nos. 77-83).

[4]John Allen Krout, *Annals of American Sport*, in *The Pageant of America*, ed. Ralph H. Gabriel (New Haven, 1929), XV, 182, *Brothers of the Wind*; 198, *Discus Thrower*; 202, *Joy of Effort*; 241, *Onslaught*; 311, *Boy Scout*.

McKenzie's sculptural expression was clearly defined early in his career. Beginning in 1900 and continuing within the decade following his appointment to the University of Pennsylvania post, a pattern of certain subject groupings, stylistic characteristics, and technical qualities emerged which dominated the artist's direction and dedication for the remainder of his life. Although he excelled in various forms of sculpture, R. Tait McKenzie obviously had a strong feeling for bas-relief, using this ancient method to produce some of his finest works in rectangular plaques and circular medallions.[5] His *Skater* of 1900 (No. 1) depicts a male, lithe, nude youth with long-bladed racing skates surging forward. An early masterpiece in bas-relief is the *Joy of Effort* medallion (Pl. XIII) in which three athletes are caught leaping over a hurdle in a manner suggesting three successive moments of a specific action, reminiscent perhaps of the earlier Muybridge and Eakins photographs. This is a finished performance demonstrating the clarity, precision, and subtlety of which McKenzie was capable in his more developed work. A sense of depth is suggested by the angle of the hurdle and by the superimposition of the three figures, while the banner, garland, and text are subordinated to supplement the effect of the three figures. The meticulous rendering of anatomical detail, particularly the heads, hands, and feet, is done with assurance. This work was entered in competition at the 1912 Olympic Games and was placed permanently in the stadium at Stockholm, Sweden. Later, in 1914, the sculptor returned to this theme (No. 32); changes made in the banner, hurdle, and lettering altered the direct effect of the original design.

The challenges of medallic art inspired unique achievement in McKenzie's work. His interest in classical art was undoubtedly a factor; the tondo, or circular, shape afforded problems and possibilities similar to those which had faced the ancient Greek vase painters, gem- and die-cutters, and, later, Renaissance artists. One might note, for example, his method of stabilizing the tondo shape with horizontal and vertical elements. The manner in which the crouching runner in the *They Are Swifter than Eagles* medallion of 1912 (No. 24) almost braces his right foot against the circular edge, or the lyrical treatment of the 1929, *ICAA Swimming* medallion (No. 78), in which the tondo shape is neatly balanced by the poised swimmer, ledge, stylized waves, and three dolphins, suggests certain Greek black- or red-figured vases.

Lettering plays an important role in medallic art, not only for the thematic information given, but also as a vital part of the overall design in an abstract, decorative sense. McKenzie demonstrated an awareness of this consideration by developing the monogram signature ℞ which he reserved for this form of his art; his other productions were usually signed with his full name—''R. Tait McKenzie''—and often included the date.

[5]Medallic art has had a long history in this country. One of the earliest examples of note appeared in 1776, when the Continental Congress commissioned a three-inch diameter gold medal (now in the Boston Public Library) to be given to Washington in appreciation of his victory over the British at Dorchester Heights earlier that year. Franklin and John Adams made the arrangements in Paris with Pierre S.-B. Duvivier to execute the work. There appears to be a resurgence of interest today in this form of art, thanks to the efforts of the Franklin Mint in Philadelphia, where themes varying from reproductions of painting masterpieces to the commemoration of the comet Kohoutek are offered in silver or gold. See also Theodore V. Buttrey, Jr., ed., *Coinage of the Americas* (New York, 1973), for related material.

One of the artist's most complicated medallic designs is his *Shield of Athletes* (Pl. XX), completed in 1932 and composed of an intricate series of concentric circles with geometric divisions containing idealistic figures of athletes engaged in various field sports. The continuous frieze of a foot-race from start to finish is quite interesting, but, in general, McKenzie's masterful figure concentration is perhaps less effective here. As medallic sculpture, R. Tait McKenzie's efforts compare favorably with the work of James Earle Fraser, Laura Gardin Fraser, Robert Aitken, and Paul Manship.

In 1925 McKenzie returned to the speed-skating theme of his earlier period (No. 1) to produce one of his most dramatic plaques, *Brothers of the Wind* (Pl. XVI). Eight interlocked skaters are shown moving rapidly from left to right. The figures closer to the viewer are executed in slightly higher relief; the landscape setting, sketchily suggested by vertical tree trunks and horizontal boughs, affords an added illusion of depth and a Renaissance pictorialism not unlike the ''crushed relief'' technique of Donatello.

The artist's three-dimensional, freestanding work may be divided into several categories: the many statuettes, usually studies of individual athletes reflecting the diligent pursuit of the artist to explore and record a variety of phases of each sport; the experimental studies, including his World War I rehabilitation work; group themes; the more developed portrait renditions of specific athletes; and the formal exterior monument commissions.

His *Sprinter* (Pl. VII) of 1902, caught on the mark in a momentary, meditative pose just before propelling himself forward, suggests the potential power yet unleashed in the fluid, unified treatment of the lean body. The 1906 *Competitor* (Pl. X) suggests the intimate, everyday approach a genre artist might take to a classic pose, as the athlete bends forward to lace his track shoe. The smooth modeling of the supple body with its rippling muscles is contrasted with the rugged, textured treatment of the base, a technique which recalls Rodin and Bourdelle. *Modern Discus Thrower*, 1926 (Pl. XVIII), owes some debt to the classical copies after Myron, along with contemporary studies. The nude boxer *Invictus*, 1934 (Pl. XXI), down on one knee, marshaling his strength to rise, recalls an ancient gladiator in a Roman arena. The expressive direct modeling in clay translated into bronze, adhering to such realistic details as the suggestion of a broken nose, scar tissue around the eyes and forehead, and thickened lips, may be compared with similar sport themes by Mahonri Young, particularly the latter's *Right to the Jaw*, 1926-27, in the Brooklyn Museum. Young treats his subject in a more overt manner, however, than McKenzie, who relies on capturing the anguish within the single figure, with his adversary only implied.

McKenzie's experimental studies are sometimes not as aesthetically satisfying as his other works. His early *Masks of Facial Expression*, 1902 (Pl. VI), portraying four male heads in intense, agonized expressions suggesting ultimate physical exertion and mental strain, are executed with deft technical assurance. *Supple Juggler* (Pl. IX) presents a unique design—the figure bent over, right arm intertwined with the legs, left arm pressed in the back—the whole appearing like some organic treelike form. Chaim Gross's studies of acrobats and other performers might be compared here.

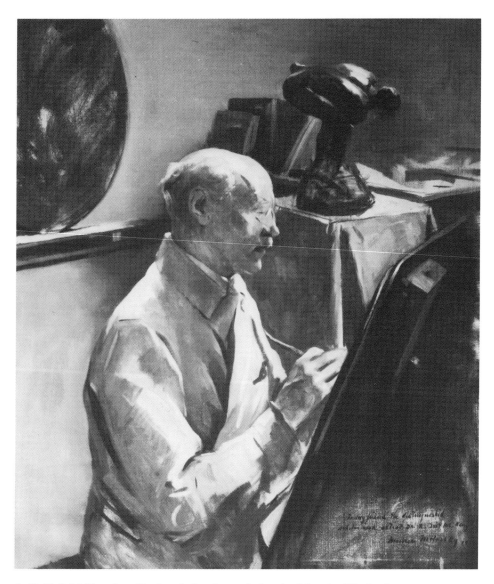

I. R. Tait McKenzie with *Supple Juggler*; painting by Maurice Morlarsky.

Grotesque, Why Not No. 1 and *Grotesque, Why Not No. 2* of 1923 (Nos. 50, 51), the first depicting a shot-putter, the second a boxer, each having two sets of arms to show two different moments in each event, were not successful productions. *Pole Vaulter* of the same year (Pl. XV) was also unsuccessful. McKenzie's attempt at solving the spatial problem by catching the vaulter in the air with the upper portions of the crossbar supports free, but encasing the remainder in a monolithic mass below, belies the soaring effect of the action, despite the clever manner in which the lower portions of the supports are incised into the base. The doorknockers (Nos. 40, 71), candlesticks (No. 41), knife rests (Nos. 44, 45, 76), and grotesques (Nos. 76, 98-101) further exemplify the variety of subjects treated by the artist, and present some of his humor as well.

It is unfortunate that McKenzie did not do more with group themes; some of his most impressive work, especially in medals and plaques, represented groups of athletes. *Onslaught* of 1911 (Pl. XII) represents over

ten figures in a writing, twisting conflict of mass movement. *Eight*, 1930 (Pl. XIX), depicts a unique design of two broad horizontals, the base below and the varsity shell above, the latter supported by the uplifted arms of eight oarsmen. Although the theme has the commonplace intimacy of a genre piece, the effective composition and ideal figure treatment transcend the anecdotal implications, creating a dramatic and unusual work of art.

McKenzie's larger outdoor monuments include his *Youthful Franklin* (University of Pennsylvania) and *Reverend George Whitefield* (University of Pennsylvania), the seated figure of *Dean West* (Princeton University), World War I memorials (at Cambridge, England; Edinburgh, Scotland; and in Canada), and the *Memorial to Jane A. Delano and 296 Nurses Who Died in World War I* (Pl. II, in Washington, D.C.). The artist's earlier exposure to the work of the Canadian monumental sculptors Hill and Hébert, his European experiences, and the artistic situation in Philadelphia have been

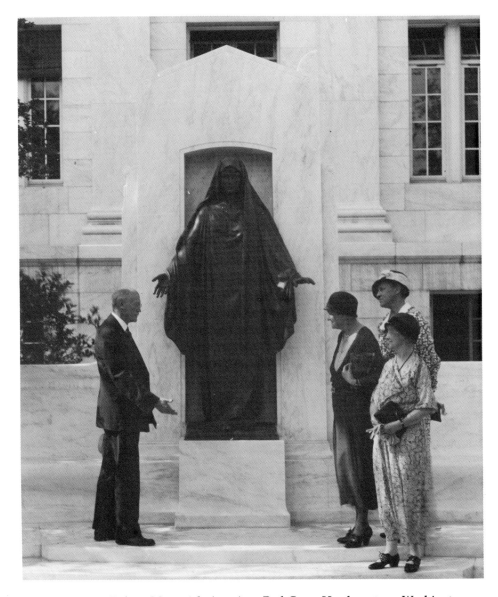

II. McKenzie at Delano Memorial, American Red Cross Headquarters, Washington, DC.

noted elsewhere. For this type of sculpture, McKenzie utilized the selective realism exemplified most effectively by Augustus Saint-Gaudens, whose lead was followed by such sculptors of monuments as French, Bartlett, MacMonnies, and Barnard in the first three decades of the twentieth century. Thus in *Youthful Franklin*, McKenzie's quest for reality included diligent research into the costume of the period (Howard Pyle helped with sketches) and a revision of Houdon's famous bust of Franklin, which had to be made more youthful. The work was commissioned in 1910 and unveiled in 1914; a bronze replica is in Brookgreen Gardens, South Carolina.[6]

An excellent example of the sculptor's later formal monumental style may be found in *Memorial to Jane A Delano*, unveiled in 1933 in the garden of the Red Cross headquarters, Washington, D.C. The bronze, seven-foot draped figure symbolizing the spirit of nursing reaches forward compassionately with outstretched arms, flanked by curved marble benches inscribed with appropriate verses from the Ninety-first Psalm.

It has been common practice in the past to point out the varied roles which R. Tait McKenzie followed and to dwell on determining when he was the artist, when the scientist, as if these were issues of paramount concern. It is an injustice to the total man, McKenzie, to isolate his achievements as though each were unrelated to the other. His medical-scientific knowledge obviously made him a better sculptor of the human figure; his artistic sensitivity and technical ability certainly aided his physical education and rehabilitation efforts. Dr. Kozar has made a significant contribution by bringing into sharper focus the relationship of R. Tait McKenzie's varied accomplishments within the areas of his endeavor.

Francis S. Grubar
The George Washington University

[6]Beatrice Gilman Proske, *Brookgreen Gardens Sculpture* (Brookgreen Gardens, S.C., 1968), 146-49.

Foreword
to the Second Edition

When asked to write the foreword to the second edition of Andrew J. Kozar's study into the life and works of Dr. R. Tait McKenzie, I accepted the invitation readily. I have known Dr. Kozar as a friend and colleague for more than 30 years and am delighted to support his endeavors. And as a sport and physical education historian who has served the field in the United States and Canada for more than 50 years, I appreciate keenly what Dr. McKenzie has meant to our profession in both countries in the 20th century.

Dr. Andy Kozar is a University Professor in the Department of Human Performance and Sport Studies at the University of Tennessee, Knoxville. Andy may well be unique in his own right, for how many football players of All-American stature do you know who have earned PhD degrees, are dedicated to the physical education profession, and have discerning appreciation of art along with some artistic talent of their own? There may be others, but I know only one: Andy Kozar. And Andy shares many of the solid character traits and professional beliefs of the now-famed McKenzie. Andy Kozar's professional versatility isn't quite as extensive as McKenzie's was (three different professions—Tait McKenzie was a medical doctor, a sculptor, and a physical educator, a person we might well label a ''Renaissance man''), but we must admire Andy's broadly based interests and talents.

What Andrew Kozar has been able to accomplish in this book is noteworthy in placing ''under one cover all the work in this classification of the man who gave the world a sculptured concept of the athletic ideal.'' Keeping the work of selected ancient Greek sculptors in mind, we might say that McKenzie brought the Classical tradition of early Greece into the 20th century more precisely than his early predecessors. Nevertheless, in assessing Tait McKenzie's work, some within the art world were (and perhaps still are) critical of his realistic, anthropometrically correct sculptures, arguing that they do not come through as art in the best sense (i.e., do not meet the aesthetic/philosophic orientation of the critic expressing an opinion). So be it; these few critics may have their say, but millions of others have expressed their favorable opinions, too. Such evaluation is ultimately a question of personal taste and, I believe, of philosophic perspective. What is important is that Dr. Kozar has assembled here all of McKenzie's work that he was able to discover, and it is depicted in the best possible light for us to enjoy. So now even art critics and historians

can follow through and investigate particular works first hand and arrive at conclusions as they wish.

As a person who was just starting his career in physical education and sport three years after McKenzie died in 1938, I have difficulty ever referring to him as "Tait." I wouldn't think of making an inadequate effort to enlarge upon Professor Grubar's insightful foreword to the original edition, written from his perspective as an art historian. Nevertheless, I have long been facinated by McKenzie's bronzes and the variety and types of subjects he covered. Though I must leave any ultimate assessment of quality to art critics and historians, I am impressed by the beauty of his artistic accomplishments, along with the insightful knowledge of anatomy displayed. I am also personally and professionally grateful for the great care and concern that Dr. McKenzie, as a medical officer in World War I, showed for the temporarily and permanently disabled men under his care abroad at that time.

What I can offer more authoritatively is a considered opinion that Tait McKenzie's contribution was truly significant to my profession. As a person who has devoted his professional life to furthering physical education and sport in the United States and Canada, I have observed first hand how this man and his work have become increasingly revered. When I entered the field in 1941 with only a liberal arts and science background, I knew nothing about Dr. McKenzie. Then, gradually, year after year and then decade after decade, I learned more and more about Dr. McKenzie's life and his contributions and experienced what they have meant to me as a professional. I saw and admired many of his sculptures in various forms, received several of his medallions as professional awards, followed in his footsteps in the profession's honorary academy, and delivered an address named after him at his boyhood home near Ottawa, Ontario. This man, along with other people like him, provided my profession and embryonic discipline with stature and stability. I am proud to have had the opportunity to follow in the footsteps of such a fine, knowledgeable, and talented person.

People like Dr. McKenzie envision their life's work as more than a mere job, even more than a trade, profession, or career. The goal in their lives is a calling to serve humankind of all ages and conditions through the opportunities provided by developmental physical activity. So it should be in every profession. In McKenzie's case, it was the field of physical education that he chose to enter, armed with a medical degree. Although such a vocational choice was not unique for a medical doctor of the early 20th century, it would indeed be so today. What is most interesting is the varying emphases McKenzie placed on each of his chosen fields depending upon changing social influences and personal choices as his life matured. His series of accomplishments would seemingly not be possible today, but we in the professions of medicine, physical education, and art can only be grateful for the contributions of Tait McKenzie to our respective histories.

The profession of physical education (and sport) continues today its struggle for full recognition over the years. This is true despite the fact that developmental physical activity guided by a qualified professional has a most valuable contribution to make to people of all ages and conditions. We have known for years that fitness of the human organism enables the individual to live life more fully. Today we also have solid evidence that planned, regular physical activity adds years to life as well.

Tait McKenzie undoubtedly gained this knowledge about sport and other developmental physical activity from his intuition, medical knowledge, and personal experience. However, he had also formed an ideal for what he considered to be the *right* kind of involvement in such a formative and developmental experience. He understood fully that competitive sport was created for humankind and that it should serve the highest and best aspirations of woman and man. The quality of this experience somehow emerges from the beauty of the human forms depicted in his sculptures. He recognized also that developmental physical activity in school physical education programs was important for all boys and girls. Further, he knew that adaptive physical activity and recreational games could serve those who for some reason had been temporarily or permanently disabled. Andy Kozar, and I as the writer of these words, also recognize the vital contribution that such movement experience can offer all men and women.

Unfortunately, there are those who, wittingly and unwittingly, through ignorance, greed, false values, or some combination thereof, don't use developmental physical activity, including highly competitive sport, in ways that can serve the finest development and the highest purposes of humans. These misguided people eventually do harm to many, often naive, individuals and to society as a whole. What makes matters so difficult is that the line that separates good from bad physical activity is often blurred. Also, we recognize that progress within participatory democracy is never a straight-line affair. This is why it is so important to reproduce and to preserve a heritage of sculptures of beautiful bodies involved in educational sport, sport that ennobles the struggle of men and women for a more peaceful and ultimately better world. Thus, I salute Tait McKenzie for his life and works, Andrew Kozar for his dedication to the preservation of McKenzie's contribution, and Rainer Martens of Human Kinetics Publishers for his publication of this fine book.

Earle F. Zeigler, Professor Emeritus
The University of Western Ontario

Preface

R. Tait McKenzie immortalized our Golden Age of Sport in bronze. His work captured both Jesse Owens and David Cecil, Lord Burghley, as well as dozens of athletes less well known, and it established him as America's foremost sculptor of sports. Medals designed by him have been treasured by champion athletes throughout the world, and many of his pieces stand as monuments to courage and effort.

McKenzie was a man of remarkable achievements in medicine, physical education, and art—three distinct fields that found a common medium of expression in his sculpture of athletes. His sculptures catch human beings in moments of physical stress, intense concentration, and relaxation; he had a way of choosing the exact pose to express a beautiful movement in a motionless, sculptured figure.

Interested, as the Greeks were, in the perfect body, McKenzie began his art career with the modeling of athletes for clinical study. The intense interest of physical educators in the late nineteenth and early twentieth centuries in anthropometry as related to ideal man inspired his first well-known sculptures, *Masks of Facial Expression* (Pl. VI), *Sprinter* (Pl. VII), and *Athlete* (Pl. VIII). After completing these anatomical, anthropometric pieces, he branched out into the wider field of sculpture, establishing his place in the art world with his statues and works of relief dealing with athletes. The Golden Age of Sport he lived in, unparalleled since ancient Greece, became the inspiration for this sculpture. Not confining himself to the champion athlete, he treated all athletes in the glorious period of athleticism he observed. He personally experienced the revival of the ancient Greek Olympics initiated by Pierre de Coubertin, a man whose ideals he admired. He actively supported these amateur games through his life—speaking, competing in art, and serving on committees. The modern Olympics, together with his total devotion to immortalizing the athlete, helped establish him as America's foremost sculptor of athletes. Medals created by him in the early part of the century (1906, 1916, 1917) are still used and valued by various athletic organizations, not only for the appropriateness and beauty of design of the medals, but also for the high athletic and academic standards advanced by their designer.

In his life, as in his art, McKenzie embraced the classical ideal of the well-rounded man—"the eager mind in a lithe body."[1] As a physician he played a prominent role in the rehabilitation of wounded and disabled veterans in England, Canada, and the United States, both during and following the First World War. His books dealing with rehabilitation were

[1] An inscription McKenzie used on the 1928-32 Olympic Shield—his *Shield of Athletes*—designed and entered into the sculpture in relief competition at the 1932 Olympics in Los Angeles.

adopted for use in the military forces of these countries. As a scholar and teacher he fought, and won respect, for physical education as a serious academic discipline.

In the world of art, however, McKenzie must have felt that the worth of his sculpture was not properly recognized. He continued to attract a number of sizable commissions for his work from 1921 until his death in 1938, but he was then, and still is, virtually ignored by the art world. Although he had a gift for successfully promoting his ideals of health and bodily exercise to reluctant Americans, his work never won the unreserved acceptance of arbiters of art.

This updated volume, a complete collection of R. Tait McKenzie's sculpture of athletes, places under one cover all the work in this classification of the man who gave the world a sculptured concept of the athletic ideal. This second edition has been redesigned, featuring new color plates of the sculptor of athletes' most important pieces of sculpture, and replacing many of the black and white plates of the previous edition. This book's purpose is to provide art students, collectors, and researchers with a pictorial knowledge of the achievements of R. Tait McKenzie. In pursuing this modest goal, however, it may also provide a basis for understanding what one remarkable man of the early twentieth century intended to do, and why.

A critical need exists for such a catalog. Although hundreds of articles have been written about McKenzie and his work, they are widely scattered throughout a diverse literature, much of it difficult to acquire. Almost a decade prior to McKenzie's death, Christopher Hussey published *Tait McKenzie: A Sculpture of Youth* (London: Country Life Ltd., 1929). Although the Hussey biography contained some illustrations of the sculptor's work, it made no pretensions to completeness; moreover, McKenzie remained very active until his death in April 1938, and a collection of his work for his later years is a requisite. He himself wanted to prepare a general catalog for the University of Pennsylvania as a part of his duties as J. William White Professor—a task not accomplished when death intervened.[2] Nor did his wife, who contemplated a similar undertaking after his death and even made some preparatory notes, ever realize her plans.[3]

In my search for R. Tait McKenzie's sculpture of athletes, I have authenticated 126 works on sports subjects, all of which are illustrated in this catalog. Within this group are the several variations of some of the sculptures; these individual renderings needed to be recorded. Some other works judged not to be related sufficiently to the area of athletics were excluded. To make this catalog as useful as possible, however, a few examples from a host of works on subjects other than sports are also included.

Preceding the comprehensive presentation of his sculpture of athletes is a biographical introduction to R. Tait McKenzie. To understand McKenzie as an artist, one must first comprehend his distinguished international repu-

[2]McKenzie mentioned this catalog in a letter of Feb. 19, 1937, to Dr. E. LeRoy Mercer, dean of the Department of Physical Education at the University of Pennsylvania. Copy in McKenzie Papers, University of Pennsylvania Archives.

[3]Ethel McKenzie received a letter about her proposed catalog from E. LeRoy Mercer dated Aug. 16, 1939. An incomplete, rough, typed copy believed to be the beginning of this catalog is extant. McKenzie Papers.

tation as a physical educator and physical therapist. Additional biographical information within the catalog illustrates how McKenzie's extensive study and practice in physical education and medicine became integral to his work as a sculptor. It should be noted that the purpose of this work precludes an exhaustive bibliography of McKenzie's publications in these areas of study and practice.

Sixteen of McKenzie's better-known pieces are featured as color plates in this book. For each of these I have summarized such information as the name of the model for the piece, the opinions of the sculptor, and the reactions of his critics, in addition to the more basic data: the title (numbered in the text to coincide with the plates and the catalog at the end of this volume), casting material used for the piece, and dimensions; notes of identifying marks, date, and signature, when such information exists; and the location where each was photographed. This primary information and black and white photos are also provided for an additional 110 pieces that are not given featured treatment, either for lack of information or because they have not attracted sufficient attention to warrant consideration as major works.

This catalog is based upon research and study in a number of repositories. The intrinsic foundation of the study was the vast amount of the sculptor's unpublished (and uncataloged) manuscripts, letters, and papers in the University of Pennsylvania Archives. Even though not all of McKenzie's personal papers were made available to the archives, this material gives one the impression that McKenzie kept every scrap of paper and memento as if he knew that someday someone would use it. Housed in the Lloyd P. Jones Gallery at the University of Pennsylvania (UP) is the J. William White Collection of McKenzie's sculpture, much of which was photographed for this catalog. The museum at the Mill of Kintail[4]—McKenzie's summer home and studio from the early 1930s to his death—located in Almonte, Ontario, as well as a private collection assembled by the late Dr. Joseph Wolffe of the Valley Forge Medical Center at Norristown, Pennsylvania, constitute two other important sources of pertinent information. The Wolffe Collection has since been donated by Dr. and Mrs. Robert Colcher (Marian W. Wolffe) for permanent display in the physical education building at the University of Tennessee, Knoxville (UTK).

[4]The Mill of Kintail was acquired in May 1972 by the Canadian Mississippi Valley Conservation Authority from the former owners, Major and Mrs. James F. Leys, who founded this memorial in 1952. Joining the government of Ontario in contributing to the mill's acquisition were the National Capital Commission, the Department of National Health and Welfare, and the Ontario Heritage Foundation. The mill is on the Indian River, a tributary of the Canadian Mississippi River which flows northward into the Ottawa River approximately 30 miles from Ottawa.

Acknowledgments

Without the ready encouragement and assistance of many individuals, this book would never have come to completion. Conversations in the late 1950s at the University of Michigan with Lenwood Paddock prompted me to undertake this project. Paul A. Hunsicker and others in the physical education department at that university provided generous and kindly encouragement in the early stages. For continued help and interest, acknowledgment is due to Henry Montoye of the University of Tennessee, Knoxville.

Financial assistance from the University of Tennessee Graduate School at Knoxville in the form of faculty research grants provided important support in the author's researching the topic thoroughly. Librarians and archivists in many libraries in this country, Canada, England, and Scotland were extremely helpful; I want especially to thank those at the Universities of Tennessee, Michigan, and Pennsylvania, McGill University, and the Ottawa Public Archives and National Library. I am grateful to a number of individuals at the University of Pennsylvania who provided valuable assistance during the collection of information—among them Dr. Leonidas-Dodson, archivist emeritus; George Munger; Bob Glascott; the late Fred Luehring, professor emeritus; Dr. Dan McGill; and Francis James Dallett, then an archivist at the university. The excellent work of Linda Fields Weinberger, Barbara Cunningham Godfrey, and Eileen Reagan in preparing the manuscript is appreciated.

The author is under special obligation to a good friend and colleague at the University of Tennessee at Knoxville, Professor Ralph Haskins, who has unstintingly given of his time and energy to read the manuscript and make many valuable suggestions.

I would like to acknowledge the following people for their involvement in preparing the second edition of this book: Bob Glascott, director of the Lloyd P. Jones Gallery of Sculpture of R. Tait McKenzie, for greatly easing the photographer's task of photographing the 16 featured McKenzie pieces in this publication; Sandra Markham, curator of the University of Pennsylvania Archives, for her able assistance in locating and supervising the archive photographer's work on the new black and white photographs used in this volume; sculptor Tim Maslyn of the Joe Brown Studio and John Grecco, for the arduous task of cleaning badly weathered outdoor bronze figures at Penn's Jones courtyard gallery in preparation for the color photographs; Rick Frey, for his encouragement in doing this version of the book; and Sue Mauck, for her editorial assistance during the completion of this project.

Finally, in a different and more personal way, I want to acknowledge the understanding, patience, and encouragement of my wife, Marian, and our children—Mary Anne, A.J., and Amy.

A Biographical
Introduction
to R. Tait McKenzie

On the occasion of his seventieth birthday, May 26, 1937, R. Tait McKenzie was toasted by his colleague at the University of Pennsylvania, E.W. Mumford. During the course of a lengthy offering at the Franklin Inn Club meeting at Valley Forge, Pennsylvania, Mumford regaled his listeners with an imaginary vignette from his subject's earliest days:

> On the morning of his first anniversary, his parents decided it was time to find out what Rab was good for. They set him in the middle of the floor, and put near him a Bible, a bottle of pills, and a lump of clay. He swallowed the pills, seized and squeezed the clay, set the Bible up on edge and jumped over it. They couldn't make up their minds what this portended, but Rab knew. He had already decided that for a man of his parts at least three professions were indicated. He was on his way to becoming a physician, a sculptor, and a professor of physical education.[1]

When McKenzie suffered a fatal heart attack in his Philadelphia home on April 28, 1938, he was still actively involved in all three professions. As physician, he had been honored by the Academy of Physical Medicine, having been elected its president for 1938. As sculptor, he was working on the memorial to Sir Arthur Doughty, Canada's distinguished archivist, and he had just completed a sketch statuette of Duke Kahanamoku, the great Hawaiian swimmer. As physical educator, he had been reelected president of the American Academy of Physical Education during the week prior to his death; at the same time the membership presented him with a beautiful scroll of highest tribute.

Moreover, McKenzie had been asked to visit St. Andrews University in Scotland that fall to receive his third honorary doctorate.[2] In a memorial address presented at a St. Andrews Society meeting in Philadelphia,

[1]Unpublished manuscript, "A Toast to McKenzie," 2, 3. McKenzie Papers.

[2]This degree was not awarded posthumously. Early correspondence indicated that McKenzie must have been present to receive the honor—a fact confirmed by a St. Andrews official, R.N. Smart, to Andrew J. Kozar, Sept. 16, 1970.

J. Norman Henry recalled cruising the Bahamas in March with his dear friend when news of the degree arrived by telegram; at the same time, McKenzie received the final agreement on his commission for the Kahanamoku statue. Henry reported McKenzie as saying that he "needed to live two years and believed such expectation likely."[3] He began to plan these two trips—the one to Scotland, the other to Hawaii—journeys that unfortunately never materialized. Yet his life had been full, constructive, and happy.

Indeed, McKenzie was so brilliantly endowed that he distinguished himself in each of his chosen callings. Without neglecting altogether his roles as physician and physical educator, this brief biography will center on his life as a sculptor of athletes.

EARLY LIFE IN CANADA

His father, William McKenzie, a young minister of the Free Church of Scotland, had settled in Almonte, Ontario, in 1858, shortly after his arrival in Canada. Coming directly to Canada after graduating from New College of Edinburgh, he spent several months as lecturer in the new Presbyterian College in Montreal; at the same time he served as an assistant to Dr. Simon Frazer in his church. In the summer of 1858 he began to travel and preach and eventually arrived in Almonte; finding here a most congenial group of people, he accepted their request that he serve as minister in their newly built Free Church. Within a year's time he brought Catherine Shiells from Scotland to the manse of the Free Church as his wife.

Three children, William Patrick, Agnes Edington, and Robert Tait, were born to the couple here. A fourth, Bertram Stuart, was born just after their father's death in 1876, during a brief stay in a new manse. The congregation then built the fatherless family a house they occupied until 1886; when their mother went to live with their sister Agnes in London, Ontario. R. Tait McKenzie was born on May 26, 1867, and spent his youth in the village of Almonte. His early formal schooling, obvious love of the outdoors, and cultured home life made its mark on the young McKenzie. His own writing about himself and the reports of others reveal his great love of acrobatics, canoeing, ice-skating, and other sports in his early youth.

In 1885, the eighteen-year-old McKenzie entered McGill University, where he eventually earned a degree in medicine, his main interest and major objective at that time. It was at McGill that he drifted quite unintentionally into physical education and art, although their role in his early life affords evidence that they were latent areas of interest. In fact, his first exhibition of art, presented in Montreal in 1899, consisted of three paintings.[4] Writing to his nephew William O'Neil on April 25, 1938, three days before his death, he briefly outlined plans for their trip to the Mill of Kintail, his beloved summer home and studio at Almonte, and added: "be sure to bring up your water colors, and I have a set of pastels with which I

[3]Undated address, 1938. Copy in McKenzie Papers.

[4]*An Old Willow, Early Spring, Apple Blossoms,* and *Craig Street, November* are listed in the *Royal Canadian Academy of Arts Catalogue—1900*, National Gallery, Ottawa, 18.

have been playing recently.''[5] It is interesting to note that he apparently continued to paint on an infrequent basis until his death.

His early admiration for his friend James Naismith, the inventor of basketball, while they were youngsters in Almonte and later when they were together at McGill, kindled in McKenzie a fascination for gymnastic activities—an enthusiasm which resulted in his becoming Naismith's assistant in teaching gymnastics at the university in the fall of 1889.[6] This assignment was both a source of pleasure and an opportunity to earn some money for his school fees.[7] Of course he could give only a few afternoons and evenings each week to teaching, for he was still involved in his course work in arts and medicine. Yet these hours represented the beginning of what he would later call his fifty years in athletics and physical education.

McKenzie's contributions in this sphere have never been fully assessed. One excellent beginning—a fine portrait of the man in his later years as seen by his peers in physical education—was, however, completed without the use of his personal papers.[8] His role as a pioneer in the establishment of physical education and as a leader in its subsequent development should be studied from the purview of his notable efforts in actual service and in his writings, both published and unpublished. The many letters he received from his colleagues in physical education indicate clearly their recognition of his knowledge and wisdom in matters of research, in the teaching and organization of all phases of physical education, and in athletics as a profession. McKenzie's work in physical activity and health formally began at McGill University in 1889 and intensified during his long tenure at the University of Pennsylvania. In one of his last talks, made before a group of professionals in physical education and athletics, he discussed the relationship of physical education and health activities to the academic program, maintaining that physical education had a mission to teach its student: (1) to preserve his health and physical efficiency; (2) to learn certain muscular skills; and (3) to conduct himself like a gentleman in the social relationships of competitive games.[9] His overall philosophy, which stressed the use of exercise as a means of keeping human beings well, rather than attempting to ''cure and patch them up after they become ill,''[10] guided his work at Penn and had its influence on physical education nationally. The profession of physical education benefited from his many speeches, articles, books, and involvement as a leader in the national organizations promoting physical education and athletics. Indeed, his own appointment at Penn as a regular faculty member—a unique status

[5]Copy in McKenzie Papers.

[6]McKenzie, ''The Measured Mile: Fifty Years of Athletics and Physical Education,'' manuscript, ch. 2, p. 7. McKenzie Papers. See also McKenzie, ''Reminiscences of James Naismith,'' *Journal of Health and Physical Education* 4 (Jan. 1933), 21.

[7]In an undated note written on Montreal General Hospital stationery McKenzie inscribed the following: ''1889-90—Naismith and I had classes together. I had 98 pupils received 475 [dollars] in fees—expense 134 profit 341. In 1890-91, 127 pupils received 602.50 in fees, expense 146 profit 456.50. In 1891-92—51 pupils received 217.50, expense 94—profit 123.50.'' McKenzie Papers.

[8]Adelaide Meador Hunter, ''R. Tait McKenzie: Pioneer in Physical Education'' (Ed.D. diss., Teachers College, Columbia University, 1950).

[9]McKenzie, ''The Relation of Physical and Health Activities to the Academic Program,'' *NCAA Proceedings* 30 (Dec. 27, 28, 1935), 87.

[10]Thomas Blaine Donaldson, ''Dr. McKenzie: The Man and His Work,'' *American Gymnasia* 1 (Nov. 1904), 100.

for a physical educator in 1904— represented his belief that physical educators and their work should be recognized as an integral part of the university curriculum. McKenzie's book *Exercise in Education and Medicine*, first published in 1909 by W.B. Saunders Company, Philadelphia, and revised in two later editions (1915, 1924), summarizes his philosophy of exercise for health. Here he presents the evolution of physical education in our country and as a physician discusses the physiological implications of physical exercise for all kinds of individuals, not just athletes. In reviewing his book, Dudley A. Sargent, Harvard University exercise specialist, stated that the greatest service it rendered the cause of education and the public in general was McKenzie's pointing out that properly applied physical exercise can do much for the handicapped—whether blind, deaf, or possessing other physical abnormalities—normally excluded from physical education programs.[11]

His early remarks and observations advocating amateurism in intercollegiate sport are still very much part of the continuing debate concerning the definitions of "amateur" and "professional" prevalent in athletics today. His paper presented at the Fifth Annual Convention of the National Collegiate Athletic Association in New York on December 29, 1910, is worthy of reviewing by those interested in the spirit of amateurism. Tracing the idea of amateurism from its beginnings in early Greek athletics and recommending the cultivation of an amateur spirit as an antidote for mistakes of the past that, in his estimation, had lowered the ethics of athletic competition, he stressed the following courses of action:

1. Keep the standard of excellence down within the reach of more men by discouraging indirect training and training under forced conditions; add more joy to the drudgery of the varsity man.
2. Diminish the class distinction between athlete and student, fostered by training tables and the privileges that the athlete so often claims as a right.
3. Consider the player first and not the spectator, for the spectacle should be an incident of the game rather than its sole object, and its practice a pastime rather than a commercial venture.
4. Cultivate by a campaign of education in player and spectator alike that wholesomeness of mind, that *Aidos* of which I have spoken so much, so important in our national life, to be found best in clean, honest, and manly sport, that makes the sting of defeat nothing when weighed with the consciousness of having won dishonorably or by subterfuge.[12]

[11]Sargent, "Book Reviews," *American Physical Education Review* 28 (Oct. 1923), 393.

[12]"The Chronicle of the Amateur Spirit," *American Physical Education Review* 16 (Feb. 1911), 94. McKenzie identifies *Aidos* in this paper as follows: "For a definition of the spirit that should actuate the gentleman amateur in his dealings with his opponents, one might well go back to the Greek word *Aidos*, for which the exact English equivalent is hard to find, but which is opposed to both insolence and servility, that, while it puts into a man's heart the thrill and joy of the fight, restrains him from using his strength like a brute or from cringing to a superior force; that wins for him honor and respect, in victory or defeat, instead of terror from the weak and contempt from the strong. It includes that scrupulous respect for personal honor and fairness that would make a team elect to risk a probable defeat rather than win through the services of those who do not come within the spirit of a gentleman's agreement. It is that spirit of modesty and dignity that obeys the law, even if the decision seems unjust, instead of piercing the air with protestations."

He gave many speeches expressing the same belief in amateurism in intercollegiate sports, but there was never any question in his mind that intercollegiate athletics should be an educational program, fully controlled by the educational institution. Later, his own efforts at Penn would result in the Gates Plan, a major revision of the conduct and administration of the intercollegiate athletic and physical education program. The new plan brought together the Council of Athletics and the Department of Physical Education, two units which had developed increasing friction over facilities and function. McKenzie viewed it as a "struggle between the ethics of an Amusement Enterprise and an Educational Institution which was abroad in the college world" and becoming increasingly serious. President Thomas Sovereign Gates, in 1931, issued the plan which brought three divisions of the University—Student Health, Physical Instruction, and Intercollegiate Athletics—under one organization called Department of Physical Education, with Dr. E. LeRoy Mercer as its new dean. McKenzie, having resigned his post in the department, said of the plan that "sports were given back to the students, teaching to the Faculty, and the deficit to the Treasurer."[13]

While McKenzie was achieving eminence as a physical educator, he also maintained an abiding interest in the humanities. In his college days he belonged to an artistic group of university men in Montreal—men with a bent toward art and literature who made his home their center of activity. Undoubtedly his membership in this Pen and Pencil Club of the late 1890s also influenced his early efforts in art. The early association with these friends, together with his lectures in anatomy and his involvement in athletics, seems to have provided the foundation for one of his first attempts at sculpture, *Masks of Facial Expression* (Pl. VI). In his unfinished manuscript "The Measured Mile: Fifty Years of Athletics and Physical Education," McKenzie credits his friend George W. Hill, a sculptor, with assisting him in his first attempt at modeling.[14] Dr. C.W. Wilson, a friend and housemate during McKenzie's early days in Montreal, later recalled introducing McKenzie to Louis Philippe Hébert, claiming that the sculptor did his first modeling in Hébert's studio. Certainly there is evidence that both Hill and Hébert exhibited with McKenzie; the first such occasion was in the Art Association of Montreal exhibit in 1901, where he exhibited with Hill. One of the two pieces of sculpture in the exhibit was McKenzie's *Skater* (No. 1), a plaster depicting a speed skater in bas-relief.[15] In the Sherbrooke Studios exhibit of the following year this same piece was shown along with *Sprinter* (Pl. VII) and a study in bas-relief, a portrait of McKenzie's mother later entitled *Mother*.

In "The Measured Mile," McKenzie explains his gradual movement away from medicine and anatomy into physical education. His final decision was made when, as director of the gymnasium at McGill, he attended

[13]McKenzie, "Physical Education at the University of Pennsylvania—from 1904 to 1931—and the Gates Plan," *Research Quarterly* 3 (May 1932), 19-26.

[14]Ch. 4, p. 2.

[15]On a 1969 visit to the Mill of Kintail, the author discovered a similar plaque which had been donated, according to Major James F. Leys, former owner of the mill, by the daughter of an artist friend of McKenzie named Bartlett. Christopher Hussey writes that there were originally two of these plaques, which measured 8 × 12 in.; he lists them as tentative works in plaster done before 1902. The plaster at the mill appears to be one of these; whether the other exists, or where, is not known.

two Christmas vacation meetings—of the American Society of Anatomists and of the newly organized Society of College Gymnasium Directors— both at Yale in 1899. Here he had an excellent opportunity to view the two groups in juxtaposition. Anatomy, concerned with the static human body, wrote McKenzie, "showed little chance for new discoveries"; on the other hand, the college gymnasium directors were "enthusiasts plough- ing a new and dertile [fertile?] field."[16] These pioneers in physical educa- tion impressed him deeply. Their spirit impelled him to cast his lot with "this group of insurgents, and to leave the conservative and safe camp of the anatomists."[17]

By 1903, as a direct result of his affiliation with his new group charac- terized by its peculiar interest in body types, McKenzie had created two pieces of sculpture, *Sprinter* (Pl. VII) and *Athlete* (Pl. VIII). Discussing these works later, he said that they were "more or less inspired or encouraged by and grew in the atmosphere of this small group of enthusiasts who felt that they were missionaries in the education world."[18] Actually, the physical culturists' fad of anthropometry which influenced McKenzie's *Sprinter* and *Athlete* was extremely short lived; with the general abandon- ment of anthropometry, the sculptor would soon turn to the more tradi- tional study of European masters. McKenzie's difficulty in sculpting in the round for the first time has been related often by himself and by others, including Frederick Tees, who was directly involved as a model.[19] The early success of these pieces and his technique in creating them caused him to be criticized during his entire career as using anthropometry and anatomical knowledge to the detriment of good art. This criticism may have been valid, but was partly due to the wide publicity given his art work—publicity which emphasized his unusual background in medicine as well as his excellent knowledge of anatomy and his work in anthropometry. By the time Christopher Hussey's biography appeared in 1929, it came as no surprise when Stanley Casson, an art critic, conceded that McKenzie was "a good draughtsman and a good modeller" but declared that "he is no sculptor in the full sense of the term." The emphasis placed by Hussey and other writers on McKenzie's two early anthropometrical works seems to have caused him to be judged unfairly. To Casson, "art is appropriate distortion," and he may have used this definition as a basis to criticize McKenzie's work. Yet he admitted that McKenzie's sculpture will "undubitably be popular" because of its realism and its expression of fine and proper sen- timents.[20]

During the summer of 1904, between jobs, McKenzie began the serious study of sculpture in the hope of rectifying that for which he was still to be criticized some twenty-five years later. These efforts were recorded in his manuscript entitled "Journal of the Tour in England and France,

[16]Ch. 4, p. 3.

[17]McKenzie named nine of these men: Dr. Dudley A. Sargent, Harvard; Dr. Edward Hitchcock, Sr., and Dr. Paul C. Phillips, Amherst; Mr. Charles Stroud, Tufts; Dr. Casper Miller, University of Penn- sylvania; Mr. George Goldie, Princeton; Dr. James A. Babbitt, Haverford; Dr. J.W. Seaver and Dr. William G. Anderson, Yale. *Ibid.*, ch. 4, pp. 3, 4.

[18]*Ibid.* ch. 4, p. 7.

[19]Tees, "Tait McKenzie," *McGill News* 23 (Autumn 1941), 29.

[20]Casson, "Review of *Tait McKenzie: A Sculptor of Youth* by Christopher Hussey, London," *Architec- tural Review* 68 (July 1930), 26.

1904.''[21] That summer he came into contact with a great many artists, studying both their approach to art and their working conditions. He visited the Royal Academy of Arts in London, where his *Athlete* was on display; expressing his pleasure with the placement of the statuette, he reported in his journal that it held its own rather well. He was impressed by G.F. Watts's equestrian statue *Physical Energy*, as well as by a number of other works at the same exhibit, which included paintings by John S. Sargent, Frank Spenlove-Spenlove, and Charles W. Furse. At all the shows he attended, McKenzie made a practice of jotting comments on the paintings in the margins of the catalogs. In London he visited John Macallan Swan, the sculptor and painter of St. John's Wood, and was deeply impressed with the man, his work, and his surroundings. Swan provided many useful hints concerning technique, and McKenzie wrote that he possessed genius, industry, and enthusiasm—''one of the great men of the modern art world.'' [22] Swan was one of the many artists who must have helped shape McKenzie's approach to sculpture during this important phase of his education in art.

After his brief stay in England, McKenzie traveled to Paris in search of a studio. Subsequently he joined a group of artists—friends with whom he regularly took dinner—among them Paul Wayland Bartlett, Richard N. Brooks, Edward A. Bell, Andrew O'Conner, Gerald Kelly, Eugene Paul Ullman, Alexander Harrison, and others. It was also during this interval in Paris that the novice sculptor recorded in his journal a visit to Auguste Rodin's studio: Rodin ''in a distraught sort of way'' took McKenzie's card ''and went on talking with the lady at his side.'' McKenzie observed that a great number of women were working the studio. Though disappointed that he had no opportunity to speak to Rodin, he was nevertheless impressed with the Frenchman's work and called him ''incomparably the greatest sculptor of our age.''

During that summer in Paris, McKenzie expressed confidence in the progress of his work; he felt that it was becoming much stronger artistically. In Paris, he began work on *Boxer* (No. 5); he completed the piece later that year and placed it on public exhibition after returning to a new job.

LIFE AT THE UNIVERSITY OF PENNSYLVANIA

In 1904, McKenzie reached a significant stage in his career when he left McGill University for the University of Pennsylvania. Prior to his trip overseas, he had agreed by cable to accept an appointment as director of physical education at Penn.[23] In ''The Measured Mile'' he explained his reasoning for the move: the newly constructed gymnasium at Franklin Field would provide a chance to put into practice those ideas of physical education as preventive medicine which he had so long advocated.

When he met with a committee from the University of Pennsylvania, in the spring of 1904, he recalled the advice given him by his former teacher

[21]A copy of this handwritten document is in the McKenzie Papers.

[22] *Ibid.*, entry of Thursday, June 2.

[23]C.S.W. Packard to McKenzie, June 9, 1904. Copy in McKenzie Papers.

at McGill Medical school, fellow Canadian and friend William Osler, who had preceded him at McGill as a student and at Penn as a teacher. The great Osler, who, not yet a baronet, was then both physician-in-chief at Johns Hopkins Hospital and a professor in that Baltimore university, had remarked concerning American methods of selecting professors: "At Harvard they ask, what do you know; at Columbia, what have you got; and at the University of Pennsylvania they invite you to dinner, set before you a cherry pie, and watch what you do with the stones." Apparently McKenzie did not undergo the cherry pie test; he merely noted that he was discreet with the committee; afterward he went to Baltimore to visit Osler, who advised him to accept the position.

At the University of Pennsylvania, McKenzie was presented with an expanded opportunity and given outstanding support in pursuing his interests in physical education and art. Various elements combined to make his work successful: his unusual tower studio,[24] the Penn Relays, the general interest in art in Philadelphia, and the presence of so many fine individuals, including one of the foremost surgeons in the country and professor at Penn, Dr. J. William White, whose will would lead to a research professorship for McKenzie twenty-seven years later. Indeed, his continued success in art might have been difficult were it not for this move. Upon arriving at the university on September 10, 1904, he remarked to a Philadelphia *Press* reporter, "I am ready for work and hope for a successful year here. I am delighted with the surroundings . . . and trust that mutual benefit will result."

And he did work, that year and every year until his death, to the mutual advantage of himself and the institution. As a matter of fact, his contributions as physician, sculptor, and physical educator benefited so many people and were accorded such widespread recognition that their scope cannot be fully determined. Yet even though he loved the University of Pennsylvania, Philadelphia, and the United States, he never gave up his Canadian citizenship. He delighted in submitting his sculpture to the Olympic art competition as a Canadian. He frequently expressed concern that people should ever forget their heritage, and to his death he remained loyal to Canada and to Scotland, his parents' birthplace.

Now established in this new and inspiring setting, he continued his sculpture of athletic themes. Some of the pieces done in these early years at the University of Pennsylvania have already been mentioned; others, which did not appear very often in his important exhibitions, were the *New York Public School Athletic League* medal (No. 11) and the two plaques entitled *Discobolos No. 1* (No. 6) and *Discobolos No. 2* (No. 7). The medal, created at the request of Dr. Luther H. Gulick and designed to serve as an individual award for track and field sports in the New York public schools, is one and one-quarter inches in diameter and on the obverse is a relief of a sprinter; it was awarded in gold, silver, and bronze. The New York public schools had already begun awarding the popular statuettes of *Sprinter* and *Athlete*. In 1912, McKenzie did a restudy of the *New York Public School Athletic League* medal, inscribed "They Are Swifter

[24]This studio, an atticlike space with long windows and stone walls, was located in Weightman Hall. The area is reached only by bringing down a jointed ladder from above. When McKenzie hoisted the ladder up he created a secluded studio in which he happily labored on his sculpture of athletes.

than Eagles''(No. 24)—a new design composed of a sprinter on his mark and below that an eagle in flight. The *Discobolos* plaques are four by seven inches and depict front and back views of the preparatory position for the discus throw. After these were completed, the front view was used in a design (No. 8) intended as a medal for the Intercollegiate Association of Amateur Athletes of America, but there is no evidence that it ever served this purpose.

McKenzie traveled extensively throughout his life. In 1907, during one of his early trips abroad, he married Ethel O'Neil in Dublin. She was the oldest daughter of John O'Neil of Hamilton, Ontario, Canada. Mrs. McKenzie was a fine musician and poet, at one time serving as head of the music department of Woman's College at Shelbyville, Kentucky. Twenty-five years after their marriage, Ethel McKenzie's collected poems would be published under the title *Secret Snow* (Philadelphia: Swain, 1932). The Philadelphia *Ledger*, reporting their wedding in October 1907, quoted her as saying, ''Dr. McKenzie and I hope to make our house the centre of a large circle of musical and artistic people.'' Their interest in the arts made them friends around the world; throughout their marriage their talents complemented each other. The McKenzies had no children.

McKenzie's summer trip abroad in 1910 had an especial import, for it was then he met E. Norman Gardiner and Percy Gardner, noted researchers and writers on Greek sculpture. McKenzie's meeting with these scholars at the Ashmolean Museum, Oxford, proved to be highly significant to his future success as a sculptor of athletes.[25] These experts expressed their admiration of McKenzie's work in their studies of ancient Greek athletics, and Percy Gardner eventually drew a favorable comparison between *Athlete* and the art of Greece. Moreover, E. Norman Gardiner's popular book *Greek Athletic Sports and Festivals* (London: Macmillan, 1910) profoundly influenced McKenzie's work in general and contributed specifically to his paper on amateurism presented at the December 1910 National Collegiate Athletic Association meeting.[26] As McKenzie predicted then, Gardiner's study remained for some time the authority on Greek athletic sports. Conversely, McKenzie exerted a great deal of influence on Gardiner's *Athletics of the Ancient World* (Oxford: Oxford University Press, 1930). Several years earlier, as editor of a series of physical education books for Lea & Febiger, a Philadelphia publishing house, he corresponded with Gardiner and advised him on the preparation of this book, hopeful that it would be published in his own series; however, it was finally issued by Oxford University Press. In the preface Gardiner noted, ''I have also included illustrations of the athletic bronzes of my friend, Dr. R. Tait McKenzie. They are the nearest parallel to the athletic art of Greece.''[27] Unquestionably this longstanding friendship with Percy Gardner and E. Norman Gardiner and their comparison of his work with that of classic antiquity did much to shape McKenzie's image as a sculptor.

His growing reputation was also enhanced by exhibitions overseas. In a collection of American art shown at the Roman Exposition of 1911 and

[25]McKenzie, ''Diary of Summer, 1910,'' entry of July 11. Copy in McKenzie Papers.

[26]''The Chronicle of the Amateur Spirit.''

[27]See illustrations nos. 30-32 facing p. 63 of Gardiner's book: *Athlete*, *Modern Discus Thrower*, and *Sprinter*.

intended to be, as the catalog said, characteristic of the prevailing tastes and ideals in the United States at this day, McKenzie had five pieces of his athletic sculpture displayed: *Athlete* (Pl. VIII), *Supple Juggler* (Pl. IX), *Competitor* (Pl. X), *Relay Runner* (Pl. XI), and the recently completed football group, *Onslaught* (Pl. XII). Exhibiting by invitation in this important show established a period characterized by a strong tendency to reproduce nature in accurate detail and to revert to the ideals of Greek and oriental art. This was also a time in which American sculpture cultivated the form for form's sake, producing studies as aesthetic ends in themselves. McKenzie adhered to this practice and devoted himself to sculpture in the nude— thus giving classical permanency to various phases of modern athletics that he considered so eminently important throughout his life.

Although his sculpture of athletes in the round continued to receive attention during this period of his life, McKenzie's portraits in relief also began to be noticed. Charles Wharton Stork, a poet and professor at Penn, writing in the *Old Penn Weekly Review*, compared his work to that of Franz von Lenbach, the "modern master painter" who studied and rendered each person individually.[28] Indeed, claimed Stork—and later critics echoed him—McKenzie's reliefs were his most perfect achievements: "His technical affiliations are with such realists as Dalou and Meunier, men who tried to interpret modern life as intimately in bronze as Millet did on canvas, and it is in portraits that such attempts are certain of success."[29] At this juncture in McKenzie's art career, when several recognized European exhibitions had begun to display his work, the New York Metropolitan Museum of Art purchased two pieces—*Supple Juggler* and *Competitor*—for its permanent collection.

During a trip to Brussels in 1910 he visited a showing of medals, making many notes and sketches and regarding the exhibit as a liberal education in this delicate art. He was particularly impressed with the work of James Earle Fraser, whose portraits he regarded as "most beautiful and tasteful," and with that of Augustus Saint-Gaudens, which had the "modern and individual touch" in this art. Each, McKenzie observed, possessed distinct individuality. McKenzie declared in his Journal of 1910 that he, in turn, would try to work as a medalist in like manner, always attempting to preserve his individuality.[30]

Shortly thereafter McKenzie completed what many critics consider his finest work in relief—*Joy of Effort* (Pl. XIII)— which was set into the wall of the great stadium at Stockholm on the occasion of the 1912 Olympics. The piece, showing three runners clearing a hurdle, is a story in itself. Two years later he made some alterations in the design, the most notable change being seen in the position of the hurdle. With the possible exception of the *Playground and Recreation Association* (Nos. 26-28) and *New York Public School Athletic League* medals, both used as awards by large organizations, *Joy of Effort* enjoyed greater circulation than any other work in relief he ever did. Though he was to be honored time and again for this

[28]"R. Tait McKenzie: Sculptor," *Old Penn Weekly Review* (University of Pennsylvania) 9 (Dec. 17, 1910), 327.

[29]*Ibid.*, 328, 329.

[30]Fraser's best-known piece in the round is *End of the Trail*; he also designed the buffalo nickel. Saint-Gauden's most popular work as a medalist is his design of the 1907-33 U.S. twenty-dollar gold piece.

piece, few, if any, were aware of his bitter disappointment when it was first displayed in Stockholm in early June 1912. His frustration is mirrored in the handwritten notes kept by his wife:

> Tait who has been much worried over the obscurity of the Joy of Effort of which no one seemed to have known its existence. We went just to see it finding it well hung in a gray frame on a gray wall, but among very [illegible] and cheap array of exhibits. . . . Tait has been fuming and fussing about it and I believe there is a plan . . . to have it presented by the American Committee to the Swedish Nation . . . to be placed in the wall of the new stadium. Tait gives the bronze and the committee [illegible] the cost of installation. Tait feels much about it like a parent whose favorite child has been insulted. I can fuss. I can not see why he should present it to the Swedish Nation, although I suppose it is better that something should happen to it [than] that it should return entirely unnoticed. When I think of the very heart's blood that went into the making of it I feel rather indignant. Tait does not seem to be having a very good time in Stockholm.[31]

In his own handwritten notes for a catalog made twenty years later, McKenzie named many persons they met at various social functions in Stockholm—among them members of the Swedish, Russian, and British nobility and, for the first time, the founder of the modern Olympics, the Baron Pierre de Coubertin.[32]

Colonel Robert M. Thompson, then president of the American Olympic Committee, officially presented *Joy of Effort* to Crown Prince Gustav Adolph of Sweden; the favorable review accorded the medallion, despite the McKenzies' early pessimism concerning the obscurity of its original display, prompted its being bestowed as a gift. Although at the time McKenzie seems to have had mixed emotions regarding this whole incident, eventually he must have been pleased to have the medallion associated with the Olympic Games which he so enthusiastically supported. Beginning with the St. Louis Olympics of 1904, he attended all but one of the celebrations of the Olympics held during his lifetime; during this span of more than three decades, he always attended as a participant—either as a member of the Olympic Committee or as an artistic competitor.[33]

In 1911, only seven years after he had come to Philadelphia, McKenzie received his first commission for a statue, one of Benjamin Franklin ordered by the Class of 1904 of the University of Pennsylvania. Called *Youthful Franklin* (Pl. III), it depicts its subject as "the poor boy, coming almost in the guise of the tramp to the city where he was to win fame and fortune." Charles Wharton Stork, in "Dr. McKenzie's Recent Work in Sculpture," spoke of the "vigor and freshness" of the piece, which, he thought, had been greatly influenced in spirit by Augustus Saint-Gaudens' *Pilgrim* in Philadelphia and Paul W. Bartlett's equestrian *Lafayette* in the court be-

[31]See Ethel McKenzie's untitled and unpaged notes about their trip to the 1912 Olympics. McKenzie Papers.

[32]"Outline for a Catalogue," ch. 3, pp. 3, 4, McKenzie Papers.

[33]He attended the Olympics at the following places: London, 1908; Stockholm, 1912; Antwerp, 1920; Paris, 1924; Amsterdam, 1928; and Los Angeles, 1932. Poor health caused him to miss the Berlin spectacle of 1936.

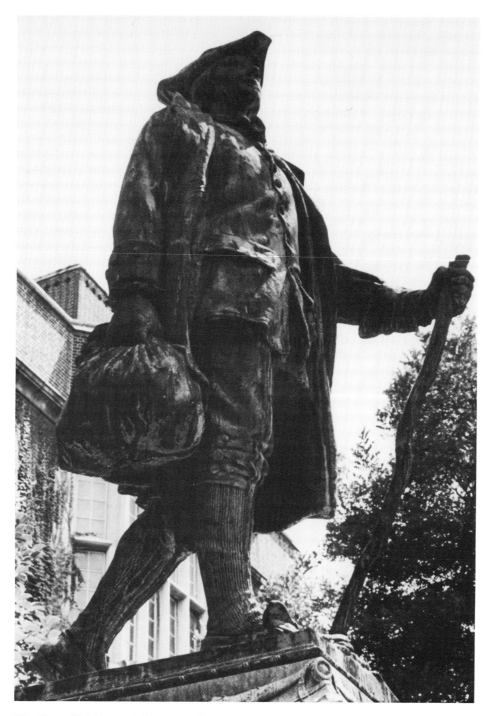

III. One of McKenzie's larger outdoor monuments is *Youthful Franklin* at the University of Pennsylvania.

fore the Louvre[34]—the work of two sculptors for whom McKenzie had recorded his admiration in his manuscript Journal of 1904.

In 1911 McKenzie also created a number of sculptural sketches of athletic figures—sketches which his biographer, Christopher Hussey, viewed as

[34]*Old Penn Weekly Review* 10 (Feb. 17, 1912), 358.

subjects that the artist was uncertain about completing as finished works.[35] McKenzie's technique began with a pencil sketch on the spot where the performer was in action; this was followed by a hasty model in clay, done as soon as possible after the initial sketch; these were cast in bronze, in most cases, years later. These sketches include *Diver* (No. 14), a ten-inch bronze figure of a swimmer on the mark prepared to plunge; *Watching the Pole Vault* (No. 37), a ten-inch plaster of an athlete with his hand behind his head; *Discobolos, Forward Swing* (No. 15), which cannot be located; it may have been destroyed while it was still the plaster figure shown in a photograph in the University of Pennsylvania Archives; three shot putters—*Shot Putter, Preparing* (No. 16), a ten-inch bronze figure holding the shot in both hands and adjusting it to the throwing hand; *Shot Putter, Resting* (No. 38), a ten-inch bronze in which the shot-putter's left hand holds the shot on his hip; and *Shot Putter, Ready* (No. 17), a ten-inch bronze figure with the shot held on one shoulder, the other arm outstretched; and *High Jumper Cleaning Shoe* (No. 18), a ten-inch plaster figure engaged in this task before jumping. A variation of this latter sketch, carrying the same title, is a ten-inch bronze figure with the left foot held higher (No. 19). Others in the same group include *Winded* (No. 39), an athlete attempting to regain his breath; *Wounded* (No. 20), a six-inch bronze figure of an athlete grasping and examining his injured ankle; *Tackle*—also known as *Head-on Tackle*—(No. 21), a four-inch bronze statuette showing a ballcarrier and a single tackler; and *Relay No. 1* (No. 22), a nine-inch bronze figure of a relay runner waiting with his left hand extended to receive the baton. Later, in 1928, another weight thrower was added—*Shot Putter, Hop* (No. 73), a ten-inch bronze. None of the other sketches in this series was cast into bronze until 1937, and the only one that McKenzie decided to do as a finished piece was a refinement of *Diver* called *Plunger* (Pl. XVII).

McKenzie's football group *Onslaught* (Pl. XII) was his last sculpture depicting athletes in the round completed before World War I. He did not return to this particular way of immortalizing the athlete of his time until 1919, when he executed *Flying Sphere* (Pl. XIV), a classic study of a left-handed shot-putter following through after his release of the iron ball. He did, however, complete the *Intercollegiate Conference Athletic Association* medal (No. 33) for scholarship and athletics in 1916 and the *ICAA Track and Field* medal (No. 34) in 1917.

WORLD WAR I ACTIVITIES

Heavily occupied with other things during the war years, McKenzie did only one piece of sculpture, which he began when he was medical officer in charge of Heaton Park, Manchester, England; it was entitled *Blighty*, and it represented a young Seaforth Highlander, a member of McKenzie's own ancestral clan, on leave in France. McKenzie's principal work during the conflict was chronicled in his publications and letters written during the Great War. The title of his book, *Reclaiming the Maimed* (New York:

[35]Hussey, *Tait McKenzie*, 40.

Macmillan, 1918), along with his papers ''Reclaiming the Maimed in War''[36] and ''The Making and Remaking of a Fighting Man: Experiences in the British Army''[37] describes rather clearly his involvement in the war as a physician. Since his graduation from McGill's medical school in 1892 he had continued his private practice, specializing in the study of spinal deformities and publishing a number of papers on these, and other, technical medical topics.[38] Although preventive medicine appealed to McKenzie, he became interested in physical rehabilitation work; in 1907 at Penn, he was appointed the first professor of physical therapy in any American university. His work in this area intensified during the war, and, at the culmination of his career, he was recognized by the Academy of Physical Medicine on October 31, 1934, as ''a pioneer in physical rehabilitation'' who

> by his painstaking and original use of physical methods brought health and usefulness to many thousands of war-maimed soldiers, and by his sound instruction raised the ethical standard in and respect for the use of physical measures in the treatment of disease as well as in the upbuilding of the physique and morale of American youth.[39]

As a Canadian volunteer in the British army, he was concerned with organizing the command depots in England for rehabilitation of the wounded so that they might return to the front or to productive civilian lives. Prior to his arrival in England, his *Exercise in Education and Medicine* had been adopted as the text for a course designed to train members of these depots.

McKenzie's medical, anatomical, and sculptural skills, vividly discussed in his paper ''Reclaiming the Maimed in War,'' made him a key figure in the literal reconstruction of disabled soldiers. In discussing some of his work with a plastic surgeon during the war, he talked about metal masks developed to cover facial deformities.

> Plastic surgery has done much for these men; but in cases in which the nose is completely destroyed a cast is made of the face. A new

[36]*Transactions of the College of Physicians of Philadelphia* 40 (1918), 31-35 [Discussion, 35-38].

[37]*NCAA Proceedings* 11 (Dec. 28, 1916), 76-80.

[38]''Therapeutic Uses of Exercise in Education,'' *Montreal Medical Journal* 22 (Feb. 1894), 561-72; ''The Accurate Measurement of Spinal Curvatures with the Description of a New Instrument for the Purpose,'' *Montreal Medical Journal* 27 (Feb. 1898), 89-96; ''Influence of School Life on the Curvature of the Spine,'' *NEA Journal of Proceedings and Addresses* 37 (July 7-12, 1898), 939-48; ''Notes on the Dissection of Two Club Feet,'' *Journal of Anatomy and Physiology* 34 (Oct. 1899), 403-9; ''The Treatment of Spinal Deformities by Exercise and Posture,'' *Montreal Medical Journal* 30 (Oct. 1901), 745-53; ''The Anatomical Basis for the Treatment of Scoliosis by Exercise,'' *Transactions of the College of Physicians of Philadelphia* 28 (1906), 54-61; ''Physical Therapeutics,'' *American Journal of the Medical Sciences* 136 (Oct. 1908), 505-11; ''The Value of Exercises in Treating Certain Cases of Acquired Inguinal Hernia,'' *International Clinics* 3 (Jan. 1912), 235-41; ''The Influence of Exercise on the Heart,'' *American Journal of the Medical Sciences* 145 (Jan.-June 1913), 69-74; ''The Treatment of Convalescent Soldiers by Physical Means,'' *The British Medical Journal* (Aug. 12, 1916), 215-18; ''The Treatment of Nerve, Muscle and Joint Injuries in Soldiers by Physical Means,'' *Canadian Medical Association Journal* 23 (Dec. 1917), 355-66; ''The Functional Reeducation of the Wounded,'' *New York Medical Journal* 108 (Oct. 19, 1918), 683-87; ''Functional Reeducation of the British Soldier,'' *Medical Record* 95 (May 17, 1919), 827-29; ''The Place of Manipulation and Corrective Gymnastics in Treatment,'' *California State Journal of Medicine* 21 (Nov. 1923), 480-82.

[39]''Dr. McKenzie Honored,'' *Pennsylvania Gazette* (Nov. 15, 1934).

nose is modelled in clay, and from a cast of this an artificial nose made of copper, silver plated and tinted to blend with the skin. It is usually held in place by a pair of glasses or by spirit gum.[40]

Returning to the university in the winter of 1916-17 after eighteen months' service in England, he remained just long enough to satisfy university residence regulations. During the spring of 1917 he continued his Canadian volunteer service as consultant and inspector of hospitals involved in reconstruction work; the following summer he continued this activity in Washington, D.C., where his book *Reclaiming the Maimed* was adopted by the United States armed forces as their official rehabilitation hospital manual.

Out of McKenzie's experiences came his great war memorials, which Hussey aptly describes as representing "a calmness that lifts . . . above sentimentality, and a beauty of form which will speak to generations to whom the war of 1914-1918 will be but pages in a history book."[41] His work on war monuments continued into 1927, when *Call* (Pl. IV) was completed and dedicated at Edinburgh. This large Scottish-American memorial, with its eight-foot bronze central figure and twenty-five-foot-long frieze, is in the Princes Street gardens. On a number of occasions he observed that this was his favorite work—a pride which easily can be understood in the light of his youthful Highland spirit and his love for his parents' motherland.

POSTWAR YEARS

It was after the war that McKenzie enjoyed his most successful exhibition, when sixty of his works were on display from July 1 to August 21, 1920, at the Fine Arts Society, New Bond Street, London. Editors and writers in leading magazines recognized all of his work and praised him.[42] Robert Allerton Parker, writing for *Arts and Decoration* and agreeing with another critic, singled out "his masterly studies of young manhood."[43] The editor of *Connoisseur* felt that these statuettes of athletes were scientifically true, adding that "they were ancient Greek in spirit and style and recalled the smaller works especially—the best period of Athenian art more than anything that has been shown in London during recent years."[44] The *Connoisseur*'s review went on to suggest that McKenzie did not so much imitate the classic Greek models as reincarnate the spirit in which they were produced. In this work he realized the form and movement of modern athletes possessing great freedom and vigor with "the same discriminating and artistic fidelity to nature that the Greeks applied to the athletes of their own day."[45] This reincarnation theme suggested by the *Connoisseur*

[40]"Reclaiming the Maimed in War," 35.

[41]Hussey, ch. 13, p. 59.

[42]"A Scientific Sculptor of the American Athlete," *Current Opinion* 69 (July-Dec. 1920), 378-80; "Current Art Notes: Sculpture by R. Tait McKenzie," *Connoisseur* 57 (May-Aug. 1920), 237; Robert Allerton Parker, "From Anatomy to Sculpture," *Arts and Decoration* 13 (Sept. 1920), 258; "The Sculpture of Dr. Tait Mackenzie," *Country Life* (London) 68 (July 31, 1920), 138-39; E. Norman Gardiner, "The Revival of Athletic Sculpture: Dr. Tait McKenzie's Work," *International Studio* 72 (Nov. 1920), 133-38.

[43]"From Anatomy to Sculpture," 258.

[44]"Current Art Notes: Sculpture by R. Tait McKenzie," 237.

[45]*Ibid.*

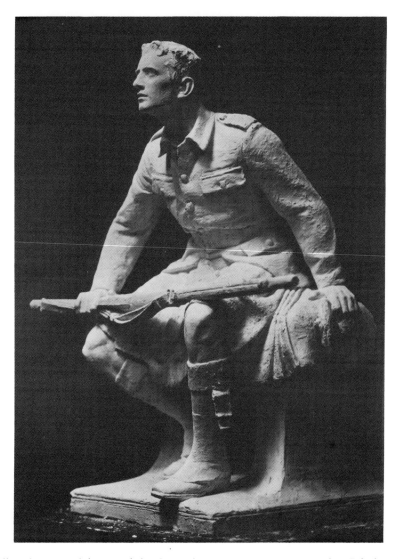

IV. *Call* is the central figure of the Scottish-American war memorial in Edinburgh;
 McKenzie's heart is buried in a church cemetery nearby.

review became the opening lines in Hussey's book *Tait McKenzie*; to the
biographer, McKenzie symbolized a reincarnation because he possessed
so many characteristics of a sculptor in ancient Hellas. McKenzie's earlier
admiration of his friends Percy Gardner and E. Norman Gardiner certainly
contributed much to the bond between his work and that of the Greek
sculptors. Indeed, E. Norman Gardiner was invited to review this London
exhibition; his analysis, which appeared some three months later in
International Studio, emphasized that McKenzie's revival of athletic sculpture
was the most characteristic feature of his art. Gardiner defended the
mechanical techniques of anthropometry in *Sprinter* (Pl. VII) and *Athlete*
(Pl. VIII), citing the example of ancient Greek artists who depicted the same
perfection of physical proportions—a perfection best exemplified in Poly-
clitus' *Doryphorus*, called by his contemporaries "The Canon," or crite-
rion, because of its flawless rendering of the ideal male figure. Modern
sculptors, according to Gardiner, were generally lacking in knowledge of

the beauties of the human body in motion. He suggested that McKenzie's work was an example from which these artists might learn.[46]

Country Life, in its issue of July 31, 1920, best summed up the status of McKenzie's art in the London exhibition:

> He can conceive that sculpture interpreting purely natural movement and expression, with careful precision, yet with judicious selection, still can say something in the Grecian Manner which the Greeks left unsaid. . . . A modern generation of critics may have at him with that fearsome epithet ''academic.'' He may accept it; and he may survive it. Really he does not need, at this hour in his career, to concern himself seriously with criticism. He has found abundant recognition. He is to be met as an exhibitor in the *Salon* and the Royal Academy. We have examples of his work in the Ashmolean at Oxford and the Fitz-William at Cambridge.[47]

The writer went on to denigrate the criticism concerning McKenzie's knowledge and use of anatomy. In his estimation, this attack in art circles on the artist's anatomical study was ''a cheap gesture and not uncommon.'' He emphasized that lack of knowledge in this area was as dangerous to the artist as was excess of knowledge. The article asserted that McKenzie did not allow his knowledge of anatomy to interfere with his overall artistic expression; on the contrary, as a specialist in both physical education and medicine, he was justified in continuing to concern himself with anthropometry and anatomy.

As a result of McKenzie's fine showing in the London exhibition, he was asked to design the Cambridge memorial *Homecoming*—an honor which could be interpreted as a seal of merit on his work. This memorial consists of an eight-foot bronze figure of a soldier in full gear on his triumphal return after the war.

The usual accolades McKenzie received during these postwar years were once somewhat comically countered by the dubious publicity given a chance remark of his concerning his concept of physical perfection. Speaking in January 1922 on the subject of proportion and human anatomy, McKenzie observed that American women were knock-kneed; shortly afterward, four girls arrived at his office with a press agent, intent on proving him incorrect. After viewing their knees, he is reported to have said, ''They were passing show girls . . . surpassing as it were.''[48] His good-natured reaction to the remark attributed to him is reflected in his January 11 letter to the editor of the Philadelphia *Bulletin*:

> Will you please convey my congratulations to the author of the story of my interview with the chorus girls in last night's paper. I feel that I was in sympathetic hands when he referred to my slightly thinning hair and he attributes me with a wit which I will find hard to live up to in the future. The humor of the story makes it almost worthwhile

[46]''The Revival of Athletic Sculpture,'' 135.

[47]''The Sculpture of Dr. Tait Mackenzie,'' 138.

[48]Philadelphia *Public Ledger*, Jan. 10, 1922; Philadelphia *Bulletin*, Jan. 10, 1922; New York *Times*, Jan. 11, 1922; New York *Herald*, Jan. 29, 1922; New York *American*, Mar. 19, 1922; and Cleveland *Plain Dealer*, Mar. 19, 1922.

to stand the amount of joshing that I will be subject to for a long time to come.

Nevertheless, in McKenzie's estimation the serious aspects of his speech were not improperly emphasized in the newspaper—a feeling reflected in his letter to John F. Black of Erie, Pennsylvania, an old friend who had indeed joshed him on the subject:

> You guessed right the first time. I am still shy and still an admirer of the ladies. Much of the recent prominence that the papers have given me has been thrust upon me but I may say they have been very good natured about it. If they would pay more attention to the things I would like to have them think about it might be better for the education world, although it might not increase the gaiety of nations.[49]

The remarks in his speech had obviously stemmed from an attempt to determine the representative figure of the typical student girl athlete, which he was considering modeling. In February 1921 he had written to Elizabeth Deaver, a physical educator in Tallahassee, Florida, asking for suggestions in arriving at "not the average figure but the eighty percent college girl." Finally, however, he never attempted to model this figure. Perhaps the Philadelphia episode, as well as a similar one a year later, when he asserted that overindulgence in athletic competition contributed to knock-knees among American women, deterred him.

Through the years McKenzie seems to have proceeded quietly with his work, undisturbed by theories of art. Interviewed by Philadelphia journalist Frances Fisher Dubuc in 1923, he offered the following comments about his mission:

> It is an artist's duty and privilege to give permanency to things that others feel but cannot express. . . . Before everything else I want to give something that people can understand and sympathize with; not merely clever studies of anatomy or classic compositions of a period buried beneath the dust of centuries. We ought to express ourselves in terms of our own times and the particular things in which we are interested. We are passing through an extraordinary period of world history, probably the most vital era of reconstruction since the world began and its significant aspects should be preserved for all time through the medium of the arts.[50]

The significant aspects of McKenzie's own time are well recorded in all his work concerning athletes and soldiers. A National Sculpture Society exhibition showing some of his work—*Plunger* (Pl. XVII) and several bas-relief portraits—was discussed by Dubuc in an article which cited the extraordinary revival of athletics since the early 1900s as the inspiration of his art.[51] Dubuc's remarks were influenced not only by the interview, but also by McKenzie's paper "Athletic Sports as an Inspiration for Sculpture"

[49]McKenzie to John F. Black, Feb. 2, 1922. Copy in McKenzie Papers.

[50]Dubuc, "A Sculptor of Soldiers and Athletes," *Arts and Decoration* 19 (June 1923), 30.

[51]*Ibid.*, 31.

presented at the Academy of Music in Philadelphia in late January 1922. McKenzie had written:

> Every great art has interpreted its own time in terms of that time and no art can depict our own time without giving a large place to its athletics. We have seen how the Egyptians, with their wall carvings and their statues have left a complete record of their daily life and doings, even to the wrestlers shown in the tomb of Beni Hassan, and this, with the great legacy left us by the Greeks must surely show us a worthy field for the artist in depicting the sports and games which form so vital a part of the education of our boys and girls and a rallying point in our national life.[52]

In 1918 Harold D. Eberlein, a colleague at Penn, published an article analyzing McKenzie's work up to that time.[53] Concerning the poses of the sculptured athletes, Eberlein described them as "natural chance attitudes . . . presented with a classical sense of ordered, well-poised composition." He drew a sharp distinction between the realism of Rodin and that of McKenzie:

> Rodin, for instance, whose frequent emotional tension is strongly dramatic, stimulates the imagination by its implied psychological message, and faithfully conveys the stormy surgings or the spirit or anguish, or the working of some powerful and subtle passion. McKenzie's athletes are expressions of bodily comeliness; they are not spiritual expositions. They would be unnatural and exaggerated if they were. They are not episodes of ephemeral impulse, but rather enduring types to which he has imparted the benison of grace and beauty. They are satisfying and convincing mainly because of their physical veracity, which is one of their strongest claims to permanent value.[54]

McKenzie received his highest compliment as a medalist when his short biography, written by Leonard Forrer, was published in the "Biographical Notices of Medallists."[55] Forrer included among the McKenzie medallions, plaques, and medals some not as yet mentioned here: the University of Wisconsin's "W" medal (No. 30), a one-by-two-inch bronze with clasps, depicting an athlete standing and supporting a standard bearing a wreathed "W" with Lake Mendota and the university buildings in the background; "W" plaque (No. 29), a five-by-nine-inch galvano of the original model for the medal, which is in the J. William White Collection at the University of Pennsylvania; the medal for the *Fencers Club of Philadelphia* (No. 31), a bronze medallion seven inches in diameter with a design showing an Italian rapier hilt; and the medal for the *Achilles Club* (No. 43), a bronze medal with the shields of Oxford and Cambridge overlaid by the Tudor rose—the reverse shows a runner carrying a torch. Commissioned in 1921 by David Cecil, Lord Burghley, a founder of the club, this medal was reduced to button size for the members' jackets.

[52]*Pennsylvania Gazette* 22 (Feb. 3, 1922), 345.

[53]"R. Tait McKenzie, Physician and Sculptor," *Century* 97 (Dec. 1918), 249-57.

[54]*Ibid.*, 256, 257.

[55]*R. Tait McKenzie* (London: Spink, 1924). Rpt. from "Biographical Notices of Medallists," *Numismatic Circular* (Nov.-Dec. 1922), 1-11.

To the praise of previous critics who had hailed McKenzie's work in low relief, Eberlein added his own, describing it as "a branch of activity even more prolific than his modeling in the round." However, he favored, as did many others, *Joy of Effort* (Pl. XIII). In discussing the sculptor's low reliefs as a whole, Eberlein went on to say:

> They show an adroit and highly effective management of planes, a degree of salience almost astounding at times, a catholic sense of appreciation, ingenuity, and imagination fertile in contributing interest, balance, and diversity to his backgrounds by the disposition and forms of lettering, by the introduction of heraldry, and by sundry small decorative details of great enhancing value.[56]

Still other honors came to McKenzie during these postwar years. In 1923 he was invited to the University of California to give two summer courses; while at Berkeley he lectured in Wheeler Hall and also had a show of his sculpture at Gump's in San Francisco from July 23 to August 4.[57] He repeated, in his lecture, his observation that "over-indulgence in athletics is robbing the American girl of her beauty." McKenzie spoke out against women's programs of physical education and athletics following the design of men's programs.[58] Again he was taken severely to task; a typical reaction was that of R.E. Squires, general secretary of the Fort Worth YMCA. He was under the impression, wrote Squires, "that Dr. McKenzie is getting one cent a word for what he writes and is trying for a record."[59] Despite such adverse comments on his lecture, McKenzie's exhibition of approximately sixty pieces was well received in California. Laura Bride Powers, reviewing for the Oakland *Tribune*, fulsomely interpreted the meaning of his work for life in California:

> Relay Runners are but one of a group of succeeding embodiments of beauty wherein line, poise, harmony evoke a smile from the soul. These "athletes in action" should not be permitted to leave California, for here in New Greece the rehabilitation of the race shall be accomplished. Climate, sea, sky, mountains, valleys, spiritual enthusiasm—these are ours. Then let us make use of these crystallizations that are literally youth and beauty for our inspiration in the working back to primitive beauty of the Golden Age—to health, to happiness, to the fullness of life.[60]

A similar interpretation, reflecting the general sense of the times, had been expressed several years earlier by Frances Fisher Dubuc in a New York *Times* article. She believed that McKenzie's sculptural expression of his love of health, of its symptoms, and of sane pleasures and activities expressed most successfully the prevailing sentiment of that era.[61]

In the San Francisco exhibit, three pieces not shown previously were listed. One of them was *Modern Discus Thrower* (No. 49), a six-and-one-half-

[56]"R. Tait McKenzie, Physician and Sculptor," 257.

[57]Berkeley *Gazette*, July 16, 1923.

[58]For full discussion see McKenzie's *Exercise in Education and Medicine*, 3rd ed., ch. 15, pp. 273-88.

[59]Fort Worth *Record*, July 19, 1923.

[60]"Artists and Their Work," Oakland *Tribune*, July 29, 1923.

[61]"Group of New Work by American Sculptors," New York *Times*, Aug. 24, 1919.

inch plaster sketch which, in 1926, McKenzie developed into a twenty-eight-inch bronze, finished work, *Modern Discus Thrower* (Pl. XVIII). In a 1928 Toronto exhibit, this statue, now finished, was listed in the catalog as *Modern Discobolos*; two years later the same statue, under its most recent title *Modern Discus Thrower*, was listed in the exhibition catalog of the Fine Arts Society in London. The others were ten-inch bronze experimental models which combined alternate poses; one, entitled *Grotesque, Why Not No. 1* (No. 50), portrays a four-armed shot-putter; the other, inscribed *The Lucky Boxer* and formally entitled *Grotesque, Why Not No. 2* (No. 51), depicts a four-armed pugilist. Hussey describes the sculptor's reasoning and method: basically, McKenzie felt that he had four statuettes in these two figures—by covering either pair of right and left arms, one finds a new practical pose. A critic writing in the New York *American* of April 27, 1924, remarked that "the Why Not #1 and #2 may be a sculptor's humor but it is a very feeble jest." Though Henry McBride wrote a generally complimentary review in the May 3, 1924, New York *Sun*, he added, "curiously enough, for so restrained an artist as this, a series of grotesques is not in the best taste."

Each of these articles was a review of a McKenzie exhibit in the Grand Central Art Galleries in New York. The catalog for this showing listed sixty-nine pieces. Again, some new works appeared in the exhibit, which was later transported to Paris during the Olympic Games of 1924 and displayed at the Georges Petit Galleries, an exhibit arranged by Louis C. Schroeder. The new pieces were *Javelin Cast* (No. 47), *Pole Vaulter* (Pl. XV), *Plunger* (Pl. XVII) (a 1925 reworking of his *Diver*), and *Ice Bird* (No. 53); for the latter, the noted Swiss skater Gustaf Lucci—whose ability as skater and teacher McKenzie admired—had served as a model, beginning a skating maneuver called an outside back spiral. The first two new pieces appeared in finished form; the latter two were not finished and cast in bronze until 1925. *Javelin Cast* was designed to be a companion piece to McKenzie's successful *Flying Sphere* (Pl. XIV). In his personal notes he indicated that it was inspired by Luella Boynton's sonnet "The Javelin Cast," which demonstrated the author's rare understanding of the movement and flight of the javelin. Though *Pole Vaulter* presented great sculptural difficulties, McKenzie solved them by utilizing a columnar structure, with the uprights and pole in low relief in the column.

During the last five years of the decade, his involvement in art intensified. His earlier successes had brought some lucrative commissions that required more of his attention,[62] leaving him increasingly less time for the heavy

[62]These commissions included the following: (1925) *Victor*, an eight-ft. war memorial statue at Woodbury, New Jersey; (1926) *Dr. Edgar Fahs Smith*, an eight-ft. memorial on the University of Pennsylvania campus; (1927) *Percy Haughton* memorial, consisting of three plaques for a Soldiers Field monument at Harvard University; *Call*, an eight-ft. figure combined with a 25-ft. frieze representing a recruiting party which comprised his Scottish-American war memorial at the Princes Street gardens, Edinburgh; *Dean Andrew Fleming West*, an eight-ft. memorial statue at the graduate school, Princeton University; *General James Wolfe*, a ten-ft. figure in Greenwich Park, London; (1931) the *Girard* memorial, an eight-ft. figure at Girard College, Philadelphia; and the *Jane A. Delano* memorial, a seven-ft. statue honoring World War I nurses at the Red Cross Building, Washington, D.C. The fact that McKenzie's records show he received $8,000 for the Haughton tablets and $43,734 for *Call* indicates his financial rewards were sizable during this period.

load of administrative work as the University of Pennsylvania's director of physical education. His many speaking engagements, too, dealt not so much with art as with his concern over the mounting professionalism in college athletics. These diverse pressures prompted his decision to leave his academic post. Attempting to resign in 1929, he was dissuaded and granted a year's leave of absence, which he devoted to sculpting. Finally announcing his resignation in late May 1931, he remarked in an interview with the Philadelphia *Public Ledger* that "my work as a sculptor demands more time than I can give to it and retain my office at the University." The University officials, however, would not permit the distinguished sculptor, physician, and physical educator to resign; instead they created a new post for him, research professor of physical education—"the first of its kind in the country." President Thomas S. Gates told the *Ledger* (May 30, 1931) that McKenzie's new assignment would "enable him to contribute through his research work, writings and sculpture to a field in which he already has made notable contributions."

During the five years leading up to his research appointment he had four major exhibitions of his work. Although he received some sizable commissions for monuments and portraits during this period, he also continued his unique sculptures of athletes. In a special showing at his Philadelphia home (2014 Pine Street) on March 1, 1925, McKenzie displayed to friends and invited members of the Philadelphia Skating Club three unfinished works: *Ice Bird* (No. 53), *Brothers of the Wind* (Pl. XVI), and *Figure Skater*, also called *Back Outside Loop* (No. 97). These pieces were direct results not only of his early Canadian background but also of his more recent study of both figure and speed skating.[63] Over the years, as an active member of the Philadelphia Skating Club, he had become interested in figure skating; he recorded in his unfinished manuscript catalog of his sculpture that "the skater comes as near to the flight of a bird as possible without wings." *Brothers of the Wind*, consisting of a panel ten feet long and about two feet in height, illustrates eight speed skaters in characteristic poses during a race. It is interesting to note that although there is no evidence in the McKenzie papers of the ten-foot version of this piece being cast in bronze, a bronze copy was purchased by the Canadian government through a 1984 Christie fine art auction in New York. It was permanently installed at the entrance to the Olympic Oval at the University of Calgary for the XV Olympic Winter Games in 1988. There are also smaller versions of this piece in bronze, one-and-one-half by five and five-and-one-half by twenty inches. The *Intercollegiate Winter Sports Union* plaque (No. 63), a six-by-nine-inch bronze, uses only the fourth figure from the lead skater in the *Brothers of the Wind* plaque. *Figure Skater* (*Back Outside Loop*) is a ten-inch bronze skater executing this difficult, but beautiful, movement. Executed also in relief, this figure was submitted, but rejected, for the *New York Skaters Club* medal (No. 109) some ten years later.

[63]McKenzie had made close observations of the champions in this sport in 1893 and 1897 and at that time had published several articles on speed skating and hockey: "Hockey in Eastern Canada," *Dominion Illustrated Monthly* 2 (Feb. 1893), 56-64; "Natural Selection, as Shown in the Typical Speed Skater," *The Journal of Anatomy and Physiology* 32 (Oct. 1897), 468-76; "International Speed-Skating," *Outing* 31 (Dec. 1897), 217-20.

Other new pieces of his athletic sculpture appeared in McKenzie's major exhibitions in Boston (1925),[64] New York (1927),[65] Toronto (1928),[66] and London (1930).[67] The Boston show included a one-half life-size piece entitled *Discobolos*, which appeared unfinished in plaster; completed in bronze in 1926, it was later to be called the *Modern Discus Thrower*. The *Pennsylvania Relay Carnival* medal (No. 52), as well as the aforementioned cast bronze medal of the frieze *Brothers of the Wind*, completed in 1925, appeared in the exhibition at Doll and Richards of Boston.

Writing in the New York *Herald Tribune* on August 5, 1928, Malcolm Vaughn asserted, "For the first time in 2000 years sport has rewon her laurels in the field of art." In this commentary on the exhibition of art at the 1928 Olympic Games, Vaughn hailed McKenzie as "America's most famous sculptor of sport" and singled out *Onslaught* and *Blocked Play* (known as *Tackle* and *Head-on Tackle*) as examples of individuals involved with forces outside themselves—forces which he viewed as "the keenest pleasure of sport itself." Vaughn added that on occasion McKenzie isolated and glorified the individual, a technique reflected in the other pieces shown at this Olympic exhibit: *Modern Discus Thrower*, *Plunger*, and *Punt* (No. 69), the latter a twenty-six-by-sixty-inch plaster tablet which was later cast in bronze for the Haughton Memorial at Soldiers Field, Harvard University. *Punt* is accompanied by two other panels in relief: a twenty-by-forty-four-inch plaster portrait of Harvard Coach *Percy D. Haughton* (No. 66) in a kneeling position and a twenty-six-by-sixty-inch plaster group scene in relief entitled *Line Play* (No. 68).

Completed two years earlier and also exhibited at Toronto was *Champion* (No. 65), a ten-inch bronze portrait of D.G.A. Lowe, the great British 800-meter winner in the 1924 and 1928 Olympic Games. In this same exhibit was McKenzie's new *Shot Putter, Hop* (No. 73), another of his many shot-putters, this one depicting the athlete just prior to his final movement forward to release the iron ball. It is a ten-inch bronze figure with leg and arm raised ready to hop across the circle. One new piece in relief, the *Athletic Sports Sesquicentennial—Philadelphia* medallion (No. 64), had been completed by June 1926, but was not shown until the Toronto exhibition. This design was struck in a bronze medallion fourteen inches in diameter as well as in a three-inch medal.

At the opening session of the International Congress on Physical Education and Sport at Amsterdam in 1928, McKenzie discussed "Athletic Sports as an Inspiration for Art." The twenty-eight years preceding these Olympic games and this speech had been called the Golden Age of modern athleticism, unparalleled since ancient Greece. McKenzie's total involvement with exercise and sports as a physician, physical educator, and sculptor established him as an expert observer and interpreter of this

[64]*Catalogue for Exhibition of Sculpture by R. Tait McKenzie*, Doll and Richards, 71 Newbury St., Boston, Dec. 30, 1925-Jan. 12, 1926.

[65]*Catalogue for Exhibition of Sculpture by R. Tait McKenzie*, Grand Central Galleries, 15 Vanderbilt Ave., New York City, Mar. 11-26, 1927.

[66]*Catalogue of Six Exhibitions*: the Canadian Soc. of Geographic Art; the Toronto Camera Club; Paul Manship; R. Tait McKenzie; Robert Holmes; Albrecht Dürer, The Art Gallery of Toronto, Grange Park, Apr. 13-May 6, 1928.

[67]*Catalogue of an Exhibition of Sculpture by R. Tait McKenzie, R.C.A.* The Fine Arts Soc., Ltd., 148 New Bond St., W.I. London, June 17-July 5, 1930.

phenomenon. Sports and games had greatly increased in number since the early Olympic games of Greece, said McKenzie, adding that the current interest in athletic sports had no parallel in history. In words that seemed a directive to himself, he remarked in his opening session speech at Amsterdam that Greek athletics were brought to us "from their poets and sculptors and it now remains for the modern artist to put into imperishable form the power, beauty and virility of this great athletic revival in the midst of which we live."

He was not alone in the world of sculpture or painting in utilizing sports, the common denominator of American life, as a subject for art. Laura Gardin Fraser, Charles A. Lopez, A. Weinman, Douglas Tilden, Jacques L. Lambert, John Frew, Charles H. Niehaus, Paul Landowski, Berthold Nebel, Alfred D. Levy, E.E. Codman, Philip S. Sears, Evelyn Longman Batchelder, Janet Scudder, and Abastenia St. Leger Eberle were the many sculptors mentioned by Richard Elmore as having contributed to the portrayal of sports in America.[68] The idea that sports had regained a position in art was discussed by Malcolm Vaughn in a review, mentioned earlier, of the Amsterdam showing of the 1928 Olympic Art Competition published about the time McKenzie made his talk at the International Congress on Physical Education and Sport. No doubt Vaughn was correct in saying that George W. Bellows, the famous artist of the prizefight, was responsible for this renewed American interest in depicting the athlete artistically, even though McKenzie had preceded Bellows by many years. Along with the work of McKenzie, the man Vaughn called "America's most famous sculptor of sport," recognition was given to Mahonri Young's prizefighters *Bantams* and to Laura Gardin Fraser's *Wrestlers*. Praising E. Weise's *Hockey Players*, Vaughn observed that the contemporary painters in this Amsterdam exhibition did not confine themselves to the traditional sports of field and stream. The great revival of sport as a subject in American art, according to the reporter, had been the "increased prominence of sport itself and our increased recognition of the poetry of motion."[69]

Although many contemporary sculptors contributed to the recording of sports, McKenzie alone perpetuated it as the dominant theme of his labors. Earlier in 1928, the year of the Olympic Art Competition, the University of Pennsylvania had awarded McKenzie the honorary degree of Doctor of Fine Arts. In the course of that ceremony President Penniman reviewed his work, observing at one point that:

> Your knowledge of anatomy and your opportunities for examining and observing athletes have been joined to the spirit of the artist and to marvelous ability to transform inert and motionless bronze into the form of men in action. Few have possessed this rare combination of accurate knowledge of the human form with the skill to make statues live.[70]

At the 1930 London Fine Arts Society exhibition of McKenzie's sculpture, some new works appeared, among them the two sketches *Upright Discus*

[68]"Sports in American Sculpture," *International Studio* 82 (Oct.-Dec. 1925), 98-101.

[69]"Sports Come-back in Art," New York *Herald Tribune*, Aug. 5, 1928.

[70]"Honorary Degrees," *University of Pennsylvania Proceedings of Commencement Day* (Philadelphia: Univ. of Pennsylvania, 1928), 39.

Thrower (No. 70) and *Winner* (No. 74). The former, a bronze figure ten inches high, illustrated a noticeable change of technique in throwing the discus; John Anderson, the 1932 Olympic champion who used this technique, was the model. *Winner* is a twelve-inch bronze figure of a runner breasting the tape, both arms held overhead. The Manchester *Guardian* of June 20, 1930, reviewing this exhibit, called *Upright Discus Thrower* "the most graceful of his many small works." *Eight* (Pl. XIX), a large bronze group of oarsmen originally designed as a lamp, was described by the *Guardian* as "an interesting and amusing decoration." Several pieces of sculpture in relief depicting athletes also appeared in this exhibit, one of them *Lord Burghley* (No. 75), a portrait plaque of David Cecil, the 1928 Olympic champion for the 400-meter hurdles. For artistic reasons, McKenzie later changed the position of the hurdler's rear leg, even though he was aware that the new position (No. 126) would be technically incorrect; while the original position would have appeared odd to the ordinary observer, it was an accurate representation of proper hurdling technique. Making an alteration in order to create a more artistic interpretation was most unusual for McKenzie, who prided himself on illustrating the athlete using up-to-date knowledge of correct performance techniques.

Beginning as early as 1915 McKenzie's work had become a part of the Intercollegiate Conference Athletic Association awards system with his ICAA medal for scholar-athletes.[71] This three-inch bronze depiction of an athlete leaning over a book with sports implements at his feet was modeled by McKenzie while on active military duty in England; the reverse of this scholarship medal (No. 35) has the nine shields of the original participating universities on a wreath; in the center are a ribbon and the inscription "For Scholarship and Athletic Prowess." The design was changed with the addition of Michigan to the conference (No. 36). Writing subsequently about the medal, McKenzie remarked cryptically that it was "not a successful design." This medal was followed in 1917 by the *ICAA Track and Field* medal (also called *Three Runners*), a three-inch bronze which shows three stages of the stride. The artist developed his portrayal of the racing stride still further in his 1932 *Shield of Athletes* (Pl. XX), also known as *Olympic Sheild*, or *Olympic Buckler*. Here a footrace showing every movement of the racing stride completely encircles the perimeter of the plaster medallion, sixty inches in diameter. The London exhibition of 1930 was the first to show the new three-inch bronze medals McKenzie designed for the ICAA champions in *Tennis, Swimming, Wrestling, Gymnastics, Fencing,* and *Golf* (Nos. 77-82). The tennis and swimming medal designs were commissioned in June 1925, but rejected by the ICAA officials.[72] Between 1925 and 1928, McKenzie did a number of rough plaster sketches for swimming medals (Nos. 55-57). In one instance—when the ICAA medal for tennis (Nos. 58-61) was chosen—he recorded his disagreement with the group commissioning his work. In his notes he insisted that his study in plaster for the tennis medal, which showed a player stripped to the waist and

[71]The ICAA organization, incorporated in May 1905, was an outgrowth of the earlier Intercollegiate Conference of Faculty Representatives which first met in Feb. 1896. The popular designation of this organization is the "Big Ten" or "Western Conference."

[72]*ICAA Faculty Representatives Meeting Minutes* (Chicago: Intercollegiate Conference, 1925), June 15, 1925; Sept. 8, 1925.

wearing long trousers, waiting to receive the ball, was a better composition than that approved for use; he later made the same remark about his study for golf (No. 122), representing a player dressed and carrying his golf bag on his shoulder. The minutes of a December 1928 meeting of the faculty representatives of the ICAA show that Frederick W. Luehring of the University of Minnesota moved that the officials authorize McKenzie's preparation of the conference sports medal designs. After over six decades these medals are still in use in the Big Ten Conference.

Some time earlier conference officials had purchased a bronze copy of McKenzie's one-half life-size *Competitor*, to be awarded the winner of the outdoor track and field meets.[73] It was decided that the school which won three outdoor track and field meets would keep the trophy permanently; in December 1927 *Competitor* was officially awarded to the University of Michigan, victor in the 1923, 1925, and 1926 meets.

The postwar period of McKenzie's life leading to the J. William White professorship was a highly productive and successful one. Christopher Hussey's *Tait McKenzie*, first published in 1929, did much to publicize the achievements of this remarkable man. The reviews of this biography praised McKenzie once again as the artist whose work reflected great anatomical knowledge, but lacked the aesthetic significance of some modern work.[74] Despite the adverse criticism, McKenzie's work remained popular, with many foundries casting his work.[75]

J. WILLIAM WHITE PROFESSORSHIP

It has already been remarked that in 1931 the University of Pennsylvania trustees, cognizant of McKenzie's wish to resign and devote more time to sculpting, moved swiftly to retain the distinguished faculty member. As J. William White Research Professor of Physical Education, he was provided with the freedom and finances to concentrate on his work as a sculptor. The chair was funded from the bequest to the University by Dr. White, a professor of surgery and a firm believer in scientific physical education for all students; he was a close friend of McKenzie until his death on April 14, 1916. Though the will did not mention art in any way, the trustees evidently viewed McKenzie's sculpture as a worthy contribution ''for the promotion of physical education and athletics,'' as it directed.[76] The funds enabled McKenzie to continue working as an artist and to have cast in bronze many of his sculptures interpreting athletic action; he intended that the collection, which became the University's J. William White Collection, should become permanent. Yet this work of casting,

[73]*Ibid.*, June 22, 1923.

[74]See the following reviews of Hussey's biography of McKenzie: *New Statesman* 34 (Jan. 11, 1930), 448; *Christian Science Monitor*, Mar. 8, 1930; *Apollo* 11 (Mar. 1930), 201; *Creative Art* 6 (Apr. 1930), 300; *American Magazine of Art* 21 (May 1930), 300; and *Connoisseur* 86 (Aug. 1930), 120.

[75]The many foundries and casting companies involved in producing the popular McKenzie work included: P.O. Caproni and Brothers Plastic Art, Boston; Jon Williams Inc., Bronze Foundry Works, New York; Florentine Art Plaster Co., Philadelphia; T. Carli, Montreal; Roman Bronze Works, New York; Medallic Art Co., New York (now Danbury, Conn.); Prissman, Munich; Bauer, Munich; Umbrick Co., Baltimore; and Gorham Co., Bronze Division, New York (now Providence, R.I.).

[76]McKenzie, ''Studies of the Modern Athlete in Sculpture.'' This eight-page paper includes an abstract of J. William White's will. Copy in McKenzie Papers.

begun immediately, was not completed at the time of his death in 1938. A partial explanation is found in a letter written by McKenzie on February 19, 1937, to Dr. E. LeRoy Mercer, dean of the Department of Physical Education. The letter was intended to provide Mercer with basic information and to serve as a progress report concerning the J. William White Collection. McKenzie wrote, ''After the second year, my salary was cut about thirty percent from $5,000 to $3,500, owing to the depreciation of securities in which the fund was invested. As a result of this there was during the last four years a deficit of about $6,000 for what I had counted on for casting and mounting—and naturally I would like to see the collection completed and mounted during my lifetime.''[77] A comparison of the list provided Dean Mercer with the present holdings in the J. William White Collection reveals that the following pieces in plaster were not completed in bronze as originally planned: *Shield of Athletes* (Pl. XX)—or, as he called it, *Olympic Buckler*—a colored plaster medallion sixty inches in diameter; *Passing the Baton* (No. 96), a fifty-by-fifteen-inch plaster panel of relay runners in action; a sketch plaster figure nine inches high of *Jesse Owens* (No. 103), Olympic and world record holder in the broad jump; *Taking the Count* (No. 102), a four-and-one-half inch sketch of a boxer on one knee; and *Safe at First* (No. 108), a three-inch plaster sketch of two baseball players— one sliding and the other trying to tag him. McKenzie was obviously deeply disappointed in being unable to complete a project which he considered so important. However, together with several plaster sculptures, the bronzes that were cast and mounted in the way he intended have been exhibited since 1972 in the Lloyd P. Jones Gallery, named for a Penn cross-country champion and located in Gimbel Gymnasium at Penn.

Shortly after his new appointment in 1931, McKenzie was invited by the mayor of Almonte, Ontario—his birthplace and boyhood home—as a special guest to assist in the celebration of the town's fiftieth anniversary of incorporation.[78] It was during this visit that he purchased his beautiful summer home and studio, which he restored and renamed the ''Mill of Kintail'' (Pl. V) in honor of the home of the head of the McKenzie clan in the Western Highlands of Scotland. In his handwritten notes about the mill he credits the mayor with encouraging him to acquire a summer studio in that area, and suggesting as a possibility the old ''Baird's Mill'' site; McKenzie, with his good friend Major Mackintosh Bell, Canadian soldier and explorer, visited the mill and the surrounding property. McKenzie, on first seeing the old stone gristmill, wrote in his notes, ''what an amazing place, I said to myself . . . accessible but isolated . . . like the retreats of the . . . highland robbers,''[79] obviously a perfect retreat for his art work. Undoubtedly memories of his youthful activities in the area influenced his desire to acquire the place. But the owners refused to sell only the mill and the immediately surrounding property; to complete the transaction he must perforce buy fifty acres and the buildings around the mill. In his

[77]Attached to this letter is a list of McKenzie's work, complete and incomplete, for the J. William White Collection. Copy in McKenzie Papers.

[78]''Almonte Honors Famous Sculptor,'' Ottawa *Journal*, June 1, 1931.

[79]McKenzie's notes are in two scrapbooks he assembled concerning the mill. These scrapbooks, now on loan to the Mill of Kintail, belong to the McKenzie Papers.

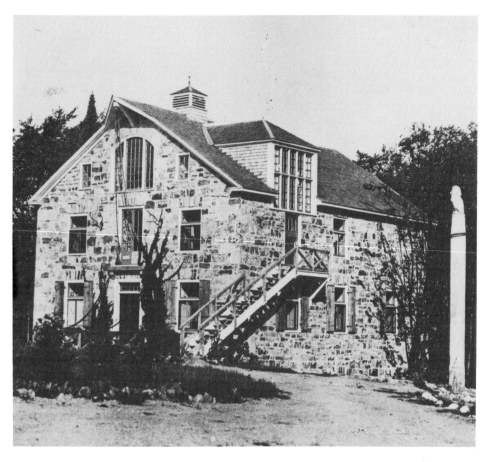

V. The Mill of Kintail, McKenzie's summer home and studio located at Almonte, Ontario.

new studio situated in the upper level of the mill, McKenzie continued to create his sculptures of athletes; his home below saw a constant stream of distinguished visitors during the next six years. Visitors at the mill, like those in his Philadelphia home, described Tait McKenzie's personality as beautiful in nature and expressed the idea that he lived, as he worked, in the nobility of great simplicity. He apparently had the love of his friends and the respect of everyone who knew him. One of his dear friends wrote briefly concerning McKenzie's delightful personality, but was quick to add that it would, however, be altogether misleading to give the impression, even by implication, that his even temper and consideration for others deprived him of the ability, under provocation, of putting on a most impressive exhibition of righteous indignation.

During this same year he designed a new medal for the Amateur Athletic Union, which was shown in Philadelphia at an Art Alliance exhibition. Named for the leader of the AAU movement, the *James E. Sullivan* medal (No. 86) was cast in gold, five inches in diameter; it was awarded for a brief time to the outstanding amateur athlete in the United States. In 1931 Bobby Jones, the champion golfer, was the first winner, receiving one of only two 14-karat gold medals ever issued. McKenzie was happy neither with its being cast in gold nor with the quality of the casting, insisting that it be adequately reproduced; it was his insistence upon quality, he reported, that caused the committee to withdraw his medal as their

award.[80] There is another variation of this medal, cast in bronze, at the University of Pennsylvania; it carries the lettered inscriptions "For Outstanding Service" and "To Good Sportsmanship" (No. 90). There is no evidence that this particular design was ever used. Examples of the sculptor's plaster studies and evidence of the artist's changes in design and inscription may be seen in three plaster cast studies (Nos. 87-89) in the J. William White Collection.

A year after he acquired the Mill of Kintail, McKenzie had one of the largest displays of his work—a total of sixty-seven pieces— at the Olympic art exhibition in Los Angeles. His old friend Charles H. Sherrill, then ambassador to Turkey, was chairman of the Fine Arts Committee for this exhibition. Some of the McKenzie entries had not been shown previously; among them was *Shield of Athletes* (Pl. XX), awarded the Olympic games third prize in the medals and reliefs competition.[81] There are a great number of athletes depicted on this beautiful medallion, which appears to represent a summary of his study of track and field athletes in action.[82] Two new works in the round and cast in bronze also appeared in this display: *Double Tackle* (No. 84) and *Grotesque Contortionist* (No. 76). The one, only four inches high but full of force and action, is a well-executed figure of two tacklers struggling with the ballcarrier. It appears to be a later development of *Tackle*, which McKenzie had completed in 1911. The other piece in the round, *Contortionist*, a knife rest, is included here with the athletic figures, although it might better be identified with the group of grotesques which McKenzie produced during the course of his career. Such works may be roughly characterized as "sport activity." Possessing a lighthearted spontaneity, they could well reflect McKenzie's playful moods, in which he developed a number of sculptured pieces depicting athletes performing physical feats—pieces designed to serve as a paper knife (No. 46), candlesticks (No. 41), knife rests (Nos. 44,45), and doorknockers (Nos. 40, 71). These were clearly a few of the many ways he expressed his keen sense of humor.

That McKenzie's display was well received is indicated by the August 1932 *Art Digest*, which quoted the report of the Olympic art exhibition by Arthur Miller, critic for the Los Angeles *Times*: "The show, on the whole, is inept, and is saved from complete mediocrity by the two rowing pictures and one boxing scene by Thomas Eakins, the boxing sculpture by Mahonri Young, and the Youth athletes modeled by R. Tait MacKenzie [*sic*]." Obviously inspired by *Joy of Effort*, Miller averred: "The sculptors come off better. Their art deals solely with the figure, and stems from the Greek athletic tradition. But not much three-dimensional art results, and this is probably because we worship, not sport as a contributing cultural

[80]See R. Tait McKenzie's untitled and unpaged notes on some of his medals. McKenzie Papers.

[81]"Prize Winners in the International Olympic Competition and Exhibition of Art as Related to Sport," Los Angeles *Saturday Night*, Aug. 6, 1932. See also Leila Mechlin, "Olympic Art Exhibition," *American Magazine of Art* 25 (Sept. 1932), 136-50. Awards in Sculpture of Medals and Reliefs: first prize, Joseph Klukowski (Poland) for *Sport Sculpture II*; second prize, Frederick MacMonnies (USA) for his *Lindbergh* medal.

[82]In the final form, there was a slight alteration from this first design; the change involved the winged figure at the top center of the medallion. In the initial model, the wings are shown in a downward position; in its final form the figure is depicted with the wings fully extended. See catalog photograph and description (Pl. XX) for more information concerning this elaborate medallion.

agent, but 'The Joy of Effort.' " Miller then used a quote from Charles Wharton Stork's sonnet on *Joy of Effort*: " 'The noblest Joy of being is to strive,' and on all sides the sculptors catch the strain of the hurdler and the sprinter."

During his preparation of the Olympic art competition display, McKenzie also composed a lecture, "The Athlete in Sculpture," for the International Olympic Conference on Physical Education held at the University of Southern California from July 25 to August 5, 1932. He called attention to the role of athletic action as a potential influence on art in the future— not a novel idea for McKenzie, but one which he seemed to voice more frequently after his appointment as research professor. Describing sculpture as "the medium peculiarly suited to portray athletic action," he added that "sculptors have always chosen the human body at rest and in action as the instrument for expressing their ideas, and nothing is more beautiful than the figure in the flower of its youth showing its strength, grace, and agility in the sports and games of the playing field, swimming pool and gymnasium." By continuing to create new pieces, McKenzie reiterated his belief that "wherever untrammeled youth is found there should be the sculptor with his appraising eye, his cunning hand, and his impressions, if an adequate interpretation is to be made of this great renaissance of athletic life and competition, in which we are living for the most part unconsciously and too often with an unseeing eye."[83]

McKenzie's "Athlete in Sculpture" appeared as the catalog title for a special exhibition at the New York Grand Central Art Galleries in February 1934. Although most of the works were familiar, a few pieces made their first appearance here; one was the unfinished *Invictus* (Pl. XXI), a boxer taking the count while resting on one knee. This twenty-inch bronze figure of a powerful boxer was posed for by Joe Brown, a former pugilist turned sculptor, while he worked in McKenzie's studio; according to the artist, it represents a boxer taking the "nine count," at which time he will get to his feet and resume fighting. Included in this same exhibition were two bronzes dealing with the same subject: a portrait statue of *William A. Carr* (No. 92), Olympic winner in the 400-meter competition, and *William A. Carr, Stride* (No. 93), a ten-inch-high figure depicting that fine runner in full stride. Carl Warton, who viewed this sketch at the Doll and Richards exhibition two years later, observed in the Boston *Herald*, "Every detail of his running technique is as perfectly reproduced as if some cosmic wizard had suddenly turned him to stone in the course of a race and had wished him up on a pedestal"[84]—a verdict which must have pleased McKenzie, since he had intended to achieve that very effect. A portrait statue of Carr, one-half life-size (No. 119), was paired with a portrait statue of *Robert Henry Michelet* (No. 104) for the William Mann Irvine Memorial Seat at Mercersburg Academy, Mercersburg, Pennsylvania. The Carr figure was based on a ten-inch sketch study of the same pose, without the light running dress and showing the Olympic shield and spiked running shoes. The subject, a remarkable athlete at Mercersburg Academy and the University

[83]"The Athlete in Sculpture," *Art and Archaeology* 33 (May-June 1932), 115-25; reprinted in *Journal of Health and Physical Education* 3:9 (Nov. 1932), 41-46, 54, 55; reprinted in the *Pennsylvania Gazette* (May 1, 1934) 410-13.

[84]Boston *Herald*, Apr. 19, 1936.

of Pennsylvania, accomplished one of the outstanding performances in the 1932 Olympics by winning the 400-meter run in the record-setting time of 46.2 seconds. The figure was modeled from life in a characteristic standing position. Because of Robert Michelet's untimely death at a youthful age, his statue was created from photographs of his easy standing pose. Varsity athlete, Phi Beta Kappa, and Rhodes Scholar, he had distinguished himself physically, intellectually, and spiritually while attending Mercersburg, then Dartmouth. McKenzie chose to show him in a bathing suit which did not "conceal the fine lines of his sturdy body, yet may be said to be the most nearly universal dress worn by American youth of both sexes."[85]

Three other sculptured items shown in the 1934 New York exhibition were *Back Outside Loop* (No. 97), a ten-inch bronze depicting a skater executing this maneuver; *Three Punters* (No. 94), a bronze medallion forty-six inches in diameter illustrating three variations of form in kicking a football; and *Javelin Cast* (No. 105), which is ten inches in diameter and cast in plaster.

In "Some Studies in the Sculpture of Athletes: Made during 1933-34," a report concerning his research for the Department of Physical Education under the J. William White Foundation, McKenzie repeated his contention that "the artistic side of this great athletic revival has been comparatively neglected." He added:

> The recording of our athletics has been left to the sports columns of the daily newspaper and the snapshots for the Sunday newspaper for the most part; and serious artists have too often been content to echo the past or follow a year or two behind the experiments of the abstractionists, the distortionists and other "ists" who have been dragging art in the dirt of Europe.[86]

He felt that sports and athletics were a vital phase of modern life—a phase which urgently needed interpretation in sculpture so that sports of his time could be preserved for the future. Yet McKenzie was not widely successful in encouraging other artists to follow his lead; in his era, he stands almost alone in taking sports as a constant theme for his sculpture. Perhaps a notable exception was Joe Brown, who, turning from boxing to sculpture, worked closely with McKenzie from 1931 until the pioneer's death seven years later.[87] If any sculptor has carried on in the McKenzie tradition, it is Brown. The theme of his work overlaps, and in some ways surpasses, McKenzie's, and his boxing pieces are excellent. Illustrations of his work appear in *Joe Brown: Retrospective Catalogue 1932-1966*.[88] Good

[85]Mercersburg *News*, Oct. 11, 1936. A few months later the swimsuited figure of Robert Michelet was replaced by McKenzie's figure of the youth in an academic gown, a gift of his father.

[86]Original report in Univ. of Pennsylvania *Faculty Research* Collection (1934), 8, 9. McKenzie Papers. This paper, presented on Apr. 26, 1935, at a meeting of the American Academy of Physical Education in Pittsburgh, was later published in the *Journal of Health and Physical Education* 6 (Sept. 1935), 11.

[87]Philadelphia *Ledger*, Apr. 15, 1934. This article featuring Joe Brown quotes McKenzie as having discovered Brown that year; however, according to Brown, he began to work with McKenzie in 1931.

[88]As the title indicates, this catalog was completed in 1966. A story, "Heroes with Clay Feet," *Sports Illustrated* (Nov. 5, 1973), 42, highlights Brown's record of activities to that date. Also see article by author: "Joe Brown: Friend, Teller of Stories, Sculptor of Athletes and Writers," *Aethlon* (Journal of Sport Literature), 6:2 (spring), 185-194.

examples of his work are *Pieta, 1944 A.D.*, a downed boxer being helped by the official; *Sprinter* (1949), semiupright runner; *Passing the Baton* (1960), relay runner extending arm with baton; and portraits of *John Steinbeck* (1960) and *Robert Frost* (1951).[89]

In the same report McKenzie included a description of his most recent creation, *Passing the Baton*, a frieze of relay runners in low relief, fifty inches long and fifteen inches high. This plaque was obviously inspired by the Pennsylvania Relay Carnival, which was celebrating its fortieth anniversary in 1934. Indeed, this single annual event had inspired nearly every piece of McKenzie's sculpture that demonstrated the track and field motif. The plaque shows eight figures, two each from four teams, making the all-important exchange of the baton—all-important because the final outcome of the relay holds the greatest interest both for the spectators and for the competing teams at the carnival.

Two years later McKenzie was accorded a high honor for a sculptor: He was selected by the Society of American Medallists to design their 1936 medal. He responded with the three-inch bronze *Strength and Speed* (No. 106), the thirteenth issue of the society. The face shows strength represented by a shot-putter, "an interpretation in relief of the statuette" *Shot Putter, Hop,* and is lettered with the biblical injunction "Rejoice Oh Young Man in Thy Youth"; on the obverse, speed is suggested by four runners, a whippet, and three wild geese. Paul Manship, a distinguished sculptor who had been asked by McKenzie to pass judgment on the medal before it was finished, wrote in reply:

> The action of the shotputter on the face of the medal is marvelous—a swell composition—I like the feeling of the lettering too—I am wondering as you ask for a candid expression of opinion—and I am probably wrong—how it would look without the dog and the goose [*sic*]—perhaps lettering substituted; for color—I am thinking that the runners would gain thereby? Altogether very fine,—congratulations.[90]

Obviously McKenzie did not agree, for he retained both dog and geese. One plaster thought to be a study for this medal is the twelve-inch *Viro non Victori* (No. 107). At about the same time he was selected to do the Society of American Medallists' medal he completed the figure-skating competition medal entitled *New York Skaters Club* (No. 109); there are a number of plaster studies for this piece (Nos. 110-13), suggesting the possible difficulty he had in arriving at the final design, a woman in a skating maneuver, her arms and legs in a momentary cross.

A number of other plaster studies done during these last years exemplify McKenzie's overall technique of first working the subject matter in clay, then casting it in plaster for study to determine its possibilities for bronze. Some of these, now displayed at the University of Pennsylvania, are medals depicting athletes in various sports activities: *Baseball Pitcher* (No. 114), *Rower* (No. 115), *Vaulter* (No. 116), *Wrestlers* (No. 117), *Girl Dis-*

[89]In 1987, Penn officials created the Harry Fields Gallery of Joe Brown Sculpture adjoining the Jones Gallery at Gimble Gymnasium. See article by author: "Genesis of a Joint Gallery of Sport Art," *Journal of Physical Education, Recreation and Dance* 60:8 (Oct. 1989), 82-85.

[90]Manship to McKenzie. Undated note in McKenzie Papers. This communication, together with a photograph of the medal is to be found in one of McKenzie's scrapbooks.

cobolus (No. 118), *Boxers* (No. 121), *Golfer* (No. 122), *Football Runner* (No. 123) using a straight arm, and the unusual medal referred to previously (No. 107), inscribed "Viro non Victori" for the loser. All these plaster studies in relief are five inches in diameter or less, with the exceptions of *Wrestlers*, which is a much smaller rectangle, and *Viro non Victori*; all appear to have been completed during 1936 and 1937. McKenzie, through the Medallic Art Company, attempted to persuade Harold I. Pratt to use one of his rejected ICAA swimming designs for the new *Harold I. Pratt Pool* medal (No. 124) at Amherst, but Pratt rejected them because of their similarity to McKenzie's ICAA swimming medal, which was already in use. The final design accepted and used for the *Pratt Pool* medal, though beautifully done, is, oddly enough, not much of a departure from the ICAA medal. The obverse of the one-and-three-quarter inch medal shows the Pratt Pool outer structure.

There is no evidence of any formal showing of McKenzie's work after the 1936 Olympics in Berlin, where he had *Invictus* (Pl. XXI) and four other pieces on display.[91] Subsequently a number of exhibitions were held, the most extensive of which was the Philadelphia Art Alliance's University of Pennsylvania Bicentennial Celebration Memorial Exhibition, September 16-27, 1940. The showing comprised seventy items, including *Wrestling Group* (No. 120), a ten-inch bronze depicting a man applying the head scissors to his opponent, and exhibited for the first time. Cast in 1937, this group was his last sculpture of athletes in the round. Although he had begun the *Duke Kahanamoku* portrait statue (No. 125) in 1938,[92] he had completed nothing more than a sketch prior to his fatal heart attack on April 28 of that same year. McKenzie had expressed in vain the hope that he might have time enough to complete both the *Kahanamoku* and *Sir Arthur Doughty* memorials. Writing in May 1937 to Clark Hetherington, an old friend in physical education, he remarked that he had "reached three score and ten and was thankful to have been given that span in health and strength." He went on to say that "anything more will be velvet, but I still hope to take some time in tapering off."[93] Perhaps he did taper off slightly; nevertheless, at his death his appointment calendar was filled to the end of May.[94] In a letter of April 4 to Lady Aberdeen[95] he wrote with pride about the honorary doctorate to be awarded at St. Andrews University, Scotland, as well as of his work on the *Kahanamoku* and *Doughty* statues: "It is extraordinary how my work is scattered abroad. The Honolulu commission will involve a trip to the islands and we are planning to make it next fall direct from the Mill so that we would not open the house [in Philadelphia] until Christmas. These plans are all of course tentative and may be changed." And so they were changed. Personal

[91]*Katalog der Olympischen Kunstausstellung*, Olympisch Kunstausstellung, Berlin, July 15-Aug. 16, 1936, p. 38.

[92]During a 1969 visit to Joe Brown's studio at Princeton University, the author was surprised to find that Brown had been working on a Duke Kahanamoku statue similar to the one begun over 30 years ago by McKenzie.

[93]McKenzie to Hetherington, May 25, 1937. McKenzie Papers.

[94]Appointment calendar, Jan.-May, 1938. McKenzie Papers.

[95]Widow of former governor-general of Canada; in 1895 McKenzie was his house physician.

friends had known for some time that McKenzie suffered from a heart ailment; the end came about five o'clock in the afternoon on April 28, 1938.

The respect and affection expressed by so many of his friends and admirers during his lifetime were repeated in the many letters which came to his widow from all over the world. McKenzie had achieved international fame not only as a sculptor but as an authority on health as related to physical activity. His career was "a triumph in industry, devotion and knowledge," wrote Sir Andrew MacPhail, professor of the History of Medicine, McGill University, to Mrs. McKenzie. He possessed a cultured and polished personality with the endearing qualities of humor, friendliness, and fairness. Almost everyone who knew the man reported that along with his artistic ability, he had a manner that was simple and sincere, with an enormous capacity for friendship with all he met.

There was an interesting posthumous sequel. One of his last requests, made in a letter to Samuel Scoville, Jr., his attorney, concerned the removal and burial of his heart in Edinburgh at the base of his *Call*, the Scottish-American war memorial. A sentimental man, he wanted his heart interred near his great work of art in the country he loved so dearly. This stipulation caused a great deal of grief for Mrs. McKenzie, but, after considerable discussion, the sculptor's heart was taken to Scotland by his good friend Dr. J. Norman Henry. Due to existing laws, Edinburgh city officials refused the request for interment in the gardens proper, but they did authorize burial on the southeast corner of St. Cuthbert's Church Old Burial Ground, which can be considered a part of Princes Street gardens. McKenzie's executors accepted the proposed site and Dr. Henry, as president of the Scottish-American Association, had accomplished his mission.[96] In poor health, Mrs. McKenzie did not make the trip. Still, "trusting in his genius," she seemed to accept her husband's final request—even though, as his brother William suggested in his December 14, 1938, letter to Mrs. McKenzie, it was "unusual."

On April 30, 1938, during the second day of the Pennsylvania Relays, thousands stood in silence with bowed heads while Gustavus Town Kirby, former president of the Olympic Committee and old friend of McKenzie, read what he called an "inadequate tribute":

> If you look at the southwest corner of this field, by the building in front of which stands Tait McKenzie's statue of Benjamin Franklin you

[96]Mrs. McKenzie sent some remarks which were read by Henry at the service: "No one knows so intimately the idealism with which my dear husband created this work in the intense admiration of his soul for the chivalry and courage of the young Scot in the great war. In passing to the care of a far away city the heart which beat with a living one in the closest and most tender devotion of thirty years of happy comradeship, I only ask the blessings of your country on both of us—Ethel Tait McKenzie." In the *Hospital Tribune*, July 10, 1967, the year of McKenzie's centennial, there appeared a photograph of McKenzie and his famous Scottish-American war memorial. Mention was made of the burial of his heart at St. Cuthbert's churchyard. Later, the *Tribune* of Sept. 25, 1967, printed the following letter to the editor from Dr. J.U. Gunter: "Late in 1938 [this must be a mistake, since McKenzie died April 28, 1938], as resident pathologist at the Pennsylvania Hospital, I was dispatched to his [McKenzie's] Philadelphia home to remove his heart for this purpose [the burial] and prepare it for shipment to Edinburgh. The partial autopsy was performed in his bedroom, on the bed where he died. I recall his extreme arteriosclerotic heart disease, with calcific aortic stenosis and actual ossification in the leaflets of the aortic valve. (Needless to say, a few small blocks were removed for sections.)"

will note that the colors are at half mast. They are thusly flown out of respect to a great man. It is fitting, that on this, the day of Tait McKenzie's funeral, we should rise and by a moment's silence show our regard and affection for this renowned representative of the University of Pennsylvania who as a sculpture [*sic*], physician, educator and administrator, knew, depicted and furthered, as few others the *joy of effort* as exemplified by these Relay Games which he knew and loved so well.[97]

Ample evidence of McKenzie's love for the Penn Relays and the athletes who competed is seen in his many pieces of sculpture recording the athlete in action—sculpture which takes on a vitality unattainable by the use of posed models or abstract compositions. His observations at a host of athletic events, his basic knowledge of the athlete's technique, and his training in anatomy enabled him to create the many careful studies illustrated in this book. For decades R. Tait McKenzie worked with eager hands to interpret in sculptural form the splendid young athletes by whom he was surrounded. Posterity must be forever thankful for the industry, devotion, and knowledge of the man who gave the world a sculptured concept of the athletic ideal.

[97]Gustavus Town Kirby to Ethel McKenzie; copy of tribute enclosed. McKenzie Papers.

The Sport
Sculpture
of R. Tait McKenzie

Color Plate Descriptions

VI. Masks of Facial Expression, 1902

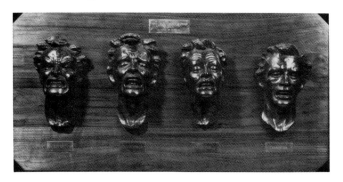

Masks expressing Violent Effort, Breathlessness, Fatigue, and Exhaustion (No. 2). Bronze, life-size; mounted on walnut. J. William White Collection, The University of Pennsylvania, hereafter cited as White Collection, UP.

This series of masks in bronze was described by McKenzie many times over the thirty years he continued to rework them. They were explained fully and were not altered after his delivery of the Nathan Lewis Hatfield Lecture before the College of Physicians at Philadelphia on November 2, 1932.[1] Three sets of these masks were cast in bronze. One set was given

to the College of Physicians, a second to the anatomical department of Cambridge University, and a third was purchased by the J. William White Fund for the University of Pennsylvania. There are plaster copies in the United States, Canada, and England.

As a college athlete McKenzie became interested in the facial contortions made by athletes during competition at about the same time he became a demonstrator of anatomy at McGill University, where he had opportunities to dissect facial muscles and to study the work of other researchers concerning facial contraction. These experiences led to his development of these unusual masks of fatigue.

Frederick J. Tees and his fellow students at McGill University helped McKenzie collect photographs of athletes during competition to be used as models for the masks. According to Tees, "The first of the masks was modeled chiefly from a snapshot of B.J. Wefers, a famous sprinter of the day, which showed his tense expression as he put everything into the finish of a race."[2]

Violent Effort, wrote McKenzie, "is the face of the sprinter or jumper or hammer thrower. The breath has been caught and held till the end of the effort, for the 100 yards is run in one breath. . . . The hammer thrower or the jumper . . . often does close his eyes at the moment of greatest effort, and the sprinter would if he did not have to keep his course."[3]

Breathlessness shows the athlete who "after the first exhilaration . . . feels an increasing uneasiness in his chest during a long race. This becomes more and more marked. He feels as if an iron band were clamped about it and as the struggle for breath becomes more and more acute his distress and anxiety increase till they are all but intolerable."[4]

The third mask, *Fatigue*, depicts the athlete getting "his 'second wind' and he goes on for the third quarter of the mile fighting an increasing lassitude, the lassitude of general fatigue."[5]

The final mask of facial expression, *Exhaustion*, occurs in the athlete just before collapse in a long-distance race. He does recover and will be prepared to exert this kind of effort again in the future.

There was some speculation concerning these masks as pieces of art. In 1914 a *Vanity Fair* editor asked, "Are they not more important for studying the expression of the emotions under violent effort than as works of art?" The author pointed out that photographs were used to create the masks and that McKenzie modeled what he measured rather than what he observed. After all, "A snapshot of a galloping horse shows the horse as it really is, while a painting of a horse by Degas shows it as it seems."[6]

T.H. Sadler, art critic for the Westminster *Gazette*, and Harrison S. Morris, writing in *International Studio*, were more complimentary. To Sadler, "they have peculiar interest, coming as they do from a man who has seen weariness and pain with a professional eye, who makes no mistakes of overemphasis, who is guided in his suggestion of facial expression and bodily attitude by knowledge of muscular relaxation and effort, and not by emotionalism."[7] Morris called the masks "an experimental work, kindred with that of Lavater, and while we know that such attempts do not produce enduring art, yet we must treat with sincere respect what has been evolved with so sincere a purpose."[8]

Notes

1. McKenzie, ''The Facial Expression of the Emotion with Special Reference to Violent Effort and Fatigue,'' *International Clinics* 4, ser. 42 (Philadelphia: Lippincott, 1932), 283-91.
2. ''Tait McKenzie,'' 28.
3. ''Facial Expression,'' 287.
4. *Ibid.*, 289.
5. *Ibid.*, 290.
6. ''The Runner, Sculpture by R. Tait McKenzie,'' *Vanity Fair* 2 (July 1914), 47.
7. ''A Scientific Sculptor of the American Athlete,'' 380.
8. ''R. Tait McKenzie, Sculptor and Anatomist,'' *International Studio* 40 (July 1910), 12.

Additional References

McKenzie, ''Notes on Facial Expressions in Fatigue and Violent Effort,'' a four-page paper presented at annual meeting of American Association of Anatomists at New Haven in Dec. 1899 and at the International Congress on Physical Education, Paris, 1900. Copy in McKenzie Papers.

McKenzie, ''Breathlessness, the Progress of Fatigue as Seen in the Face,'' *Outing* 43 (Feb. 1904), 594-98.

McKenzie, ''The Facial Expression of Violent Effort, Breathlessness, and Fatigue,'' *Journal of Anatomy and Physiology* 11 (Oct. 1905), 51-56.

McKenzie, ''Le Masque Facial dans L'Effort,'' *Aesculape* (Feb. 1925), 31-34.

McKenzie, ''Effort and Endurance,'' *Country Life* (Sept. 24, 1927), 432-33.

McKenzie, *Exercise in Education and Medicine*, 17-29.

VII. Sprinter, 1902

Crouching track figure (No. 3). Bronze, height 9 in.
Signed: R. Tait McKenzie. White Collection, UP.

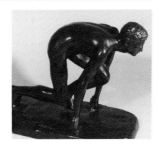

Sprinter is described as "a vivid realization of suspended energy . . . waiting to start, with every muscle quivering in tense eagerness for the signal."[1] Exhibited in London's Royal Academy in 1903 and in the Salon of Paris in 1904, this bronze statuette became McKenzie's most popular and most widely circulated piece in the round. To model the figure, he used an arithmetical mean of anthropometric measurements of the 74 best contemporary sprinters of the United States, collected by Paul C. Phillips of Amherst.[2] "A very mechanical way . . . of producing a statue," wrote E. Norman Gardiner, "but after all it was thus that the Greek sculptor consciously or unconsciously worked. Certainly there is nothing mechanical about the Sprinter."[3] At this juncture of his art career, having no studio training, McKenzie encountered many difficulties in the three years it took to complete what he called the "ideal sprinter." Several McGill University sprinters, including Frederick J. Tees, posed for this statuette.[4]

Both Charles H. Sherrill[5] and McKenzie[6] report the story of Sherrill's invention of the crouching start in sprint racing and its inspiration for this piece of sculpture. The stance presented the sculptor with a beautiful and graceful combination of lines and mass. "This effort was much praised by anatomists, but McKenzie was anxious to know what artists thought; and it was accepted . . . he scored a favorable verdict," wrote Robert Barr.[7]

A shipping list of the Jon Williams Bronze Foundry and Works, dated January 12, 1905, indicated that R.M. Ferguson sent a copy of the *Sprinter* to Theodore Roosevelt on February 3, 1903. The Fitzwilliam Museum of Cambridge, England, acquired a copy; others are to be found in many private collections. All in all more than forty bronze copies were sold, including some smaller bronzes four and three-quarter inches high; a still greater number of plaster replicas were distributed.

Notes

1. "Current Art Notes: Sculpture by R. Tait McKenzie," 237.
2. Phillips, "What Makes Man a Sprinter," *Outing* 42 (May 1903), 230-34.
3. "The Revival of Athletic Sculpture," 136.
4. Tees, "Tait McKenzie," 28, 29.
5. Sherrill, "The Origin of the Crouching Start," *Franklin Field Illustrated* 6 (Apr. 1932), 5.
6. Frances C. Healy, "Sports in Art," NBC-WJZ network radio broadcast script (Mar. 2, 1934). Interview with R. Tait McKenzie and Lawson Robertson. McKenzie Papers.
7. Robert Barr, "An American Sculptor," *Outlook* 79 (Mar. 4, 1905), 561.

Additional References

Thomas Blaine Donaldson, ''Robert Tait McKenzie, M.D.,'' *Alumni Register* (Univ. of Pennsylvania) 9 (Oct. 1904), 13.
Eberlein, ''R. Tait McKenzie,'' 249-57.
McKenzie, ''The Athlete in Sculpture,'' 115-25.
Hussey, *Tait McKenzie*, 12-15.

VIII. Athlete, 1903

A college athlete taking the grip-strength test (No. 4).
Bronze, height 16 in. Signed: R. Tait McKenzie,
1903. White Collection, UP.

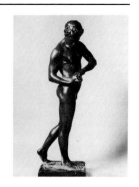

At their December 1902 convention in New York, the Society of College
Gymnasium Directors, which had commissioned the modeling of *Athlete*,
officially expressed their appreciation for its "scientific truthfulness and
artistic excellence."[1] McKenzie, in describing his method for developing
this piece, wrote that he had "obtained the average measurement of four
hundred Harvard men all of whom came within the first fifty strongest
during the last ten years [1894-1904]. . . . Taking this set of measurements
and proportions as basic, I modelled the figure of this ideal young man
of 22 years and having a height of 5 ft. 9 in., so the linear measurements
of the statue were exactly one fourth life size. . . . The athlete is about
to try his right forearm by the oval spring dynamometer."[2]

E. Norman Gardiner, in *Athletics of the Ancient World*, wrote that McKen-
zie's bronzes "were the nearest parallel" in the modern world to the sculp-
ture of the athletic era of the Greeks. "It is remarkable how closely in its
general type it [*Athlete*] agrees with the *kanon* of Polyclitus."[3] McKenzie
himself observed that the statuette is "taller and more slender than Poly-
cleitus [*Doryphoros* of Polyclitus], stouter and more heavily built than that
of Lysippus [*Apoxyomenos* of Lysippus] . . . standing between the two ex-
tremes."[4]

An article in the March 16, 1903, Montreal *Gazette* briefly described this
statuette as embodying "all the lines and curves of grace and beauty: it
also impresses the idea of solidity and strength." This piece was exhibit-
ed in Paris at the Salon in 1903 and in London at the Royal Academy of
1904. Harrison S. Morris, in 1910, was impressed with "the flowering lines"
of this piece, "that aim to imprison an ideal meaning," and "the light
and shade so justly distributed."[5] Many writers viewed *Sprinter* and *Athlete*,
McKenzie's first two pieces in the round, as exemplifying the style of clas-
sical Greek sculpture, as distinct from his later, more contemporary work,
in which he chose to immortalize "the modern athletic movement."[6]

Notes

1. Paul C. Phillips and James A. Babbitt to McKenzie, Dec. 31, 1902. McKenzie
 Papers.
2. "The College Athlete," *Architectural Record* 16 (Nov. 1904), 492.
3. Gardiner, *Athletics of the Ancient World*, 65.

4. McKenzie, ''The Search for Physical Perfection,'' *Old Penn Weekly Review* 14 (Nov. 1915), 240.
5. ''R. Tait McKenzie,'' 12.
6. Barrow Lyons, ''Modern Athlete in Sculpture by R. Tait McKenzie,'' *Mentor* 14 (Sept. 1926), 26.

Additional References

Hussey, *Tait McKenzie*, 16-20.
Eberlein, ''R. Tait McKenzie,'' 252.
Barr, ''An American Sculptor,'' 562.
Harry J. Walker, ''The Athlete in Sculpture,'' *Canadian Homes and Gardens* 11 (Dec. 1934), 46.

IX. Supple Juggler, 1906

Juggler executing ancient Scottish feat of suppleness (No. 9). Bronze, height 14 in. Marked: Copyright R. Tait McKenzie, 1906. White Collection, UP.

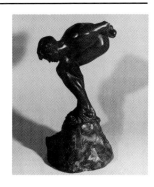

Supple Juggler depicts a boy picking up a baseball in a contorted manner. The ball has been placed at the outer edge of the left foot, and the boy has brought his right arm over the left thigh, stretching the right hand out between the ankles to grasp the ball. It illustrates a feat popular in Scotland, where a dirk is the object to be picked up in this manner. McKenzie preferred the baseball; as Mrs. McKenzie wrote, he "emphasized the faun-like character in the merriment expressed in the smiling mouth, the pointed ears, the tangled forlock [sic], even with the toes curling mischievously upward with the effort of reaching the ball."[1] T.H. Sadler, whose comments on a McKenzie exhibition were quoted in a *Current Opinion* article, described this figure as having "rhythmic pattern to a high degree of perfection, and that without the least distortion of accepted form."[2]

Supple Juggler is obviously a spry youth alive with flexibility and agility. Harold D. Eberlein wrote that the figure "is not, perhaps, comfortable to contemplate, but any one who looks at him must be thoroughly convinced of the suppleness of his wiry muscles and of his ability to unwind his contortions like a flash of lightning to assume another posture equally baffling."[3] McKenzie's biographer Christopher Hussey suggested that the "sculptural interest of the effort is in the conflicting stresses and the unusual relation of the limbs."[4] He went on to say that there was as much expression in the feet of the juggler as in his face.

In his correspondence with Daniel Chester French early in 1908, McKenzie discussed the New York Metropolitan Museum of Art's interest in purchasing *Supple Juggler*.[5] His records reveal he gave the museum liberal reductions both on this piece and on *Competitor*.[6] The bronze statuette was shown at the Royal Academy, London, in 1908, at the Salon, Paris, the next year, and at the Roman Art Exposition in 1911.

Notes

1. Ethel McKenzie, notes on *Supple Juggler*. *McKenzie Papers*.
2. "A Scientific Sculptor of the American Athlete," 379.
3. Eberlein, "R. Tait McKenzie," 256; reprinted in *Alumni Register* (Univ. of Pennsylvania) 21 (Dec. 1923), 169.
4. *Tait McKenzie*, 23.
5. Letters between McKenzie and French on this matter are dated Jan. 17, 1908, Jan. 20, 1908, and Mar. 16, 1920. McKenzie Papers.
6. McKenzie's records indicate the museum paid $150 for *Competitor* and $50 for *Supple Juggler*; these pieces normally sold for $500 and $250 respectively. McKenzie Papers.

X. Competitor, 1906

Athlete tying his track shoe (No. 10). Bronze, height 21 in. Signed: R. Tait McKenzie, 1906. White Collection, UP.

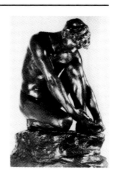

Acquired by the New York Metropolitan Museum of Art along with *Supple Juggler*, this bronze figure was exhibited in the Salon and the Royal Academy in 1907. At least nineteen copies were sold, including the one purchased by the Intercollegiate Conference Athletic Association (Big Ten) in June 1923[1] and intended as a permanent trophy for the first institution winning the outdoor track and field meet three times. It was awarded to the University of Michigan in 1927.

Of the figure, Charles Wharton Stork wrote, "Line flows so easily into line that the observer never imagines what infinite experiment and care were necessary to produce this effect of repose. And in that one word, repose, is concentrated the highest praise that can be given to such a work."[2] Harrison S. Morris, commenting in *International Studio*, was not so complimentary, remarking that "the director of physical education is a bit more apparent than the seeker for beauty."[3]

Both T.H. Sadler,[4] who was quoted in *Current Opinion*, and Harold D. Eberlein[5] expressed the idea that this placid composition showed "potential action and vigor" and suggested "tense effort in motionless metal." According to Sadler, this piece and *Supple Juggler* illustrated McKenzie's "kinship to the later and more gracious period of Greek art as well as to the classic period austere simplicity."[6] In Christopher Hussey's view, *Competitor* was executed without restrictions of measurements—an approach which freed the sculptor to "give his whole attention to harmony of form."[7]

Notes

1. *ICAA Faculty Representatives Meeting Minutes,* June 22, 1923.
2. "R. Tait McKenzie," 327.
3. "R. Tait McKenzie," 12.
4. "A Scientific Sculptor of the American Athlete," 379.
5. "R. Tait McKenzie," 256; reprinted in *Alumni Register,* 169.
6. "A Scientific Sculptor of the American Athlete," 379.
7. *Tait McKenzie,* 22.

XI. Relay Runner, 1910

Crouching competitor watching a footrace (No. 12). Bronze, height 22 in. Marked: R. Tait McKenzie, 1910. White Collection, UP.

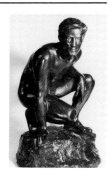

This figure, one of the many which found their inspiration at a Pennsylvania Relay Carnival, was created as a companion to *Competitor*. According to Mrs. McKenzie, Maurice Husik, Penn undergraduate, posed for both during the summers of 1906 and 1908 at McKenzie's summer studio at Noank, Connecticut.[1] Some two decades after beginning the sculpture, McKenzie described how the idea for this bronze was conceived while he watched a college two-mile relay team compete.[2] Waiting his turn, this anchor man is eagerly watching the second man of his team run. Charles Wharton Stork, discussing the sculpture in 1910, remarked it was "brimming with potential energy for the time of action" and added that "McKenzie has therefore done what every true artist does, he has idealized. The naturalism of his method should never obscure this."[3] H.D. Eberlein, writing in 1918, observed that this natural chance attitude had been presented with a classic sense of order and thus represented a well-poised composition.[4]

The art critic for *Country Life* (London), in reviewing McKenzie's 1920 exhibition at the Fine Arts Society on New Bond Street, discussed this figure. First briefly describing a relay race in order to acquaint his readers with this aspect of American athletics, the writer went on to say: "It hardly matters exactly for what 'baton' or other happening the *Relay* is on the outlook. He is crouching, tensely, keenly observant, momentarily ready to spring erect and change his rest into swift movement. He tells us all we need to know."[5] Hussey echoed these sentiments and added his impression that "McKenzie was consciously striving to simplify his surfaces so far as was consistent with significance. . . . The back of the figure is a subtile and exquisite piece of modelling, the planes few, slightly but firmly differentiated, and all delicately related into a light, clean rhythm. . . . The form has the inevitability of the finest art."[6]

Notes

1. Ethel McKenzie, notes on *Relay Runner*. McKenzie Papers.
2. "The Rewards of Athletics," undated manuscript written about 1926. McKenzie Papers.
3. "R. Tait McKenzie," 235.
4. "R. Tait McKenzie," 256.
5. "The Sculpture of Dr. Tait McKenzie," 139.
6. Hussey, *Tait McKenzie*, 24.

XII. Onslaught, 1911

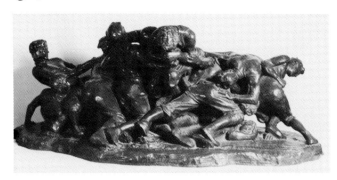

Football group in a line play through center (No. 13).
Bronze, height 15 in.; length, 36 in.; width 21 in.
Marked: R. Tait McKenzie, copyright 1911. White
Collection, UP.

This football group according to McKenzie, ''represents a line play . . .
the spirit of the American game, in which the offense crashes through the
line.''[1] Mike Murphy, an athletic trainer at the University of Pennsylva-
nia, assisted McKenzie by repeatedly putting the reserves through this
wedge play, so that the sculptor could study the spirit of this then-
characteristic maneuver of the American game. A number of the models
were University of Pennsylvania football players, among them T. Trux-
tun Hare, Robert G. Torrey, Bill Hollenback, B.R. Murphy, and Carl Wil-
liams.[2] Mrs. McKenzie's notes mention one additional person—LeRoy
Mercer—who posed on the many Sunday mornings when the sculptor
was working on this group.[3] Because of McKenzie's pressing duties as
director of physical education, it took him five years to complete this piece.

Onslaught was cast in bronze early in 1911 and exhibited in a number
of places, including the Roman Art Exposition of that same year.[4] Report-
edly, the original was placed in the Montreal Art Association Gallery.[5]
A leading periodical, offering a detailed description of the group, com-
pared its general composition to ''that of a breaker, the contours being
convex on one aspect and concave on the other. The heads of the attack-
ing team form the ragged crest of the surge, the lines leading up to the
ball.''[6] To Harrison S. Morris, commenting on the still-uncompleted work
in 1910, *Onslaught* depicted ''a great cluster of college men full of vitality
and eager movement, of the onrush of unconquerable spirit, of the unity
of purpose which animates a team and above all, full of a sense of beau-
ty.''[7] Several years later, the editors of *Christian Advocate* devoted an arti-
cle to this ''unity of purpose'' expressed by Morris, stating that ''the
sculpture will stand as perhaps the most perfect plastic representation of
intense physical exertion concentrated upon a common end that has been
achieved by any modern sculptor.''[8]

Notes

1. McKenzie to Healy, notes for "Sports in Art" broadcast. McKenzie Papers.
2. New York *Post*, Jan. 27, 1911.
3. Mrs. McKenzie, notes on *Onslaught*. McKenzie Papers.
4. Philadelphia *Inquirer*, Mar. 16, 1911; *Catalogue of the Collection of Pictures and Sculpture in the Pavilion of the United States of America at the Roman Art Exposition* (Rome: Forzani, 1911), 55.
5. Harold Elliott, "R. Tait McKenzie, B.A., M.D.," *McGill Medical Undergraduate Journal* 4 (Dec. 1934), 92.
6. "The Onslaught; A Football Group by R. Tait McKenzie," *Century* 81 (Apr. 1911), 919.
7. "R. Tait McKenzie," 14.
8. "Not as One That Beateth the Air," *Christian Advocate* 91 (Jan. 27, 1916), 1.

Additional References

R.J. Phillips, "The Sir Winston Churchill Trophy," *Journal of Canadian Association for Health, Physical Education and Recreation* 26 (Dec.-Jan. 1960), 36.

Powers, "Artists and Their Work."

Henry McBride, New York *Sun*, May 3, 1924.

Vaughn, "Sports Come-back in Art."

XIII. Joy of Effort, 1912

Three athletes clearing a hurdle (No. 25). Bronze, diameter 46 in. Marked: The Joy of Effort, RTM. White Collection, UP

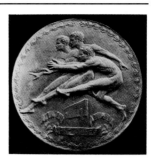

This medallion is recognized by those who know McKenzie's work as the most beautiful of all he produced. The beauty of the hurdler in action impressed the sculptor in 1910 as he studied these athletes on Franklin Field in preparation for carving the medallion. As he wrote in his notes, "the one in the foreground has more than a passing resemblance to LeRoy Mercer, than a champion in the game [hurdling]."[1] But Mrs. McKenzie, writing many years later, suggests that the true inspiration for *Joy of Effort* came to the sculptor during one of their many ocean trips, some twenty-five years earlier, when, "standing one day by the rails of an ocean liner, we watched a school of porpoises leaping through the waters. . . . He compared the circular upheaval of the round bodies, rhythmically appearing and disappearing to the similar movement of a flock of runners taking the hurdles."[2]

Reviewing the sculptor's work in 1912, McKenzie's friend Charles Wharton Stork proposed still another source of inspiration for *Joy of Effort*, observing that "the arrangement of the three men clearing the hurdle was suggested by a Greek coin representing a chariot, the flash of the horses' legs being here rendered by those of the athletes. The modern relief, like the ancient, is a pure delight." Stork went on to predict the future popularity of the piece—a forecast proven true by the wide use of copies as prizes and awards. "Both in vividness of conception and felicity of arrangement this promises to be a masterpiece," wrote the reviewer.[3] McKenzie was pleased with Stork's commentary; two decades later he wrote that the race depicted "is admirably described in Stork's sonnet on the medallion."[4]

Exhibited at the 1912 Olympic Games in Stockholm, *Joy of Effort* was offered by the American section of the International Olympic Committee to Sweden as a permanent memorial to the fifth Olympiad. After it was accepted, the original forty-six-inch plaster medallion was cast into bronze and set into the wall beside the stadium entrance. Moveover, McKenzie was honored by the King of Sweden in 1914 when he was presented with a silver medal in recognition of his work in athletic sculpture.[5] In that same year the medallion was altered slightly in both the scrolling and the hurdle position; the newer version is signed "R. Tait McKenzie, 1914."

J. H. Crocker, secretary for the Far Eastern Athletic Association contest committee of 1915, wrote McKenzie to tell him of their adoption of his hurdler design as a souvenir medal for their games. He then added,

I was surprised a few days ago to learn that the Publicity Committee had adopted this same idea for their advertising in China, but unfortunately in redrawing made some changes which I would not have agreed to. . . . I hope you will overlook the fact that the committee did not have time to ask your permission, and your reward will come in the fact that you have been a party in spreading physical education in China.[6]

Both Eberlein and Hussey added their praise for this beautiful medallion. Eberlein called it "one of McKenzie's finest achievements in low relief,"[7] and Hussey declared that, "as a work of humanist art, it must be placed very high among the masterpieces of modern times."[8]

Notes

1. McKenzie, notes concerning *Joy of Effort*. McKenzie Papers.
2. Ethel McKenzie, notes on *Joy of Effort*. McKenzie Papers.
3. "Dr. McKenzie's Recent Work in Sculpture," 359.
4. "The Athlete in Sculpture," 39. Charles Wharton Stork's sonnet, "The Joy of Effort: On a Relief Medal of Three Hurdlers by R. Tait McKenzie," appeared in *Century* 74 (July 1912), 449.
5. Philadelphia *Ledger*, Oct. 20, 1912; Philadelphia *Bulletin*, Dec. 4, 1914.
6. "The Far East Athletic Games: Committee Adapts Dr. R. Tait McKenzie's Sculpture," *Old Penn Weekly Review* 13 (May 22, 1915), 1097; "Chinese Adopt American Design as Coat of Arms of New Republic," Philadelphia *Ledger*, June 2, 1915.
7. "R. Tait McKenzie," 257.
8. *Tait McKenzie*, 45.

XIV. Flying Sphere, 1920

Shot-putter just after releasing the iron ball (No. 42).
Bronze, height 18 in. Marked: R. Tait McKenzie,
1920. White Collection, UP.

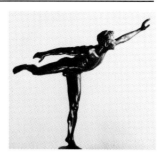

Flying Sphere represents the moment of balance just after the reverse in putting the shot. McKenzie likened the pose of this figure to *Flying Mercury*: ''The long line from the left hand to the right foot, for he is left-handed, carries the movement uninterrupted across the body in an upward curve—of power and exhilaration.''[1]

According to Mrs. McKenzie, the *Flying Sphere* ''was commissioned by Justice Jasper Yates Brinton in the memory of his brother, a brilliant young Pennsylvania athlete.''[2] E. Norman Gardiner, author of *Greek Athletic Sports and Festivals* and *Athletics of the Ancient World*, called this piece McKenzie's finest representation of the athlete in action: ''The composition is superb, the long delicate curve of the body and the short reversed curve of the open hand beautifully suggesting the curved flight of the shot.''[3]

In an *International Studio* article of 1925, Richard Elmore stressed the point that twentieth-century sculptors had provided their athletes with far more action than had the ancient sculptors, citing as an example *Flying Sphere*, ''a revelation of power and virile grace.''[4] Hussey called this piece of sculpture the most decorative of all McKenzie's work. Indeed, it was so well received at a London exhibition that the complete issue of the bronzes was sold immediately.[5] The statuette inspired a sonnet by the sculptor's wife, who included it in her collection of poems. The first four lines read:

> *Like as the athlete flings the flying sphere*
> *To reach that goal his eye still follows far,*
> *Our dreams take flight through each succeeding year,*
> *Forever soaring towards some distant star.*[6]

Notes

1. McKenzie, notes concerning *Flying Sphere*. McKenzie Papers.
2. Ethel McKenzie, notes on *Flying Sphere*, McKenzie Papers.
3. E. Norman Gardiner, ''The Revival of Athletic Sculpture,'' 138.
4. ''Sports in American Sculpture,'' 101.
5. Hussey, *Tait McKenzie*, 31.
6. ''The Flying Sphere,'' *Secret Snow*, 133.

XV. Pole Vaulter, 1923

Athlete at the peak of his vault (No. 48). Bronze, height 18 in. Marked: R. Tait McKenzie, *Fecit* 1923. Nelson B. Sherrill of the University of Pennsylvania vaulted over a bar thirteen feet in height May 1923; the world may yet produce an athlete who will soar higher by another foot.[1] White Collection, UP.

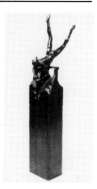

McKenzie elaborated on his rationale for sculpting the vaulter on a column both in a published article and in his personal notes.[2] This obviously did not satisfy Hussey, who later criticized this piece adversely, writing that it "must be relegated to a secondary category" because the sculptor had used two antagonistic methods—the naturalism of the figure and the highly stylized shaft.[3]

McKenzie believed that the modern athlete, in performing the pole vault, presented a series of sculptural poses delightful to the eye;[4] yet he was keenly aware of the difficulties of supporting a vaulting figure in a piece of sculpture. When, in San Francisco, he saw a carving in jade of a seal set on a column with clouds and birds on all four sides, the problem was solved: "Thereupon I set up a square shaft on which the pole and the uprights were shown 'in relief,' the surfaces decorated along the same motif of clouds and birds to give the impression of greater height."[5] Obviously he caught the natural pose of the vaulter at the precise moment when he was pushing with his arms to propel his body over the bar. Speaking about this sculptural technique during the 1924 exhibition at the Galleries Georges Petit in Paris, he said, "Look at this vaulter. His pose is instantaneous. Yet every line, every position is correct. That is because I memorise the figure in action. . . . I catch their poses on the wing, as it were."[6]

Nelson Sherrill posed for the sculptor during the winter of 1923-24, prior to his world's indoor record vault of thirteen feet in May 1925. Sherrill posed by walking around the studio on his hands. As McKenzie wrote, "the muscles of his arms and shoulders [were] acting almost in exactly the manner of the 'push up' in the pole vault."[7]

Notes

1. Although this was, for the time, an impressive vault, setting the world's indoor record, it was not an overall record: in 1912 Robert A. Gardner of Yale had jumped 13 ft., 1 in. McKenzie could hardly have foreseen that, today, using fiberglass poles, vaulters would be soaring over 19 ft.
2. "The Pole Vaulter," *Pennac News* (May 1925), 14; notes on *Pole Vaulter*, McKenzie Papers.
3. Hussey, *Tait McKenzie*, 33.

4. R. Tait McKenzie, ''The Athlete in Sculpture,'' *Supplement to the Proceedings of the Institute of International Relations. Ninth Session, International Olympics Conference on Physical Education, Special Series of Lectures*, University of Southern California (July 25-Aug. 5, 1932), 35.
5. Notes concerning *Pole Vaulter*, McKenzie Papers; Hussey, *Tait McKenzie*, 33.
6. ''Pictures Olympic Games in Marble,'' New York *Herald*, July 16, 1924.
7. ''The Pole Vaulter,'' 14.

XVI. Brothers of the Wind, 1925

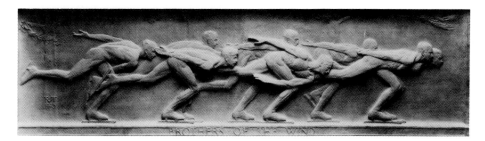

Frieze of eight speed skaters racing (No. 54). Colored plaster, height 33 in., length 120 in. Marked: RTM 1925, Brothers of the Wind. White Collection, UP.

Hussey, McKenzie's biographer, offered high praise for his frieze of speed skaters as art. He wrote that McKenzie's *Brothers of the Wind* "touched the highest limit of athletic art. Its unquestionable beauty gives it a place of its own among the master-pieces of relief."[1]

McKenzie's initial inspiration for this sculptural relief of eight speed skaters depicted in typical, beautiful movement came from close observation of races in Montreal in 1897.[2] The inherent strength and beauty of the event and its participants impressed him so that he thoroughly studied the activity in the late 1800s. This research, related to his interest in anthropometry, resulted in a series of articles in which he analyzed the speed skating technique and the physical development of championship-level speed skaters of that era.[3] As a result of his study, McKenzie found that the speed skater's driving force in the skating stroke came from the flat foot and not the toe, resulting in greater thigh and lower-back development and less calf muscle development in these athletes.[4]

Modeling on this panel of interwoven skating figures didn't begin until 1921, nearly twenty-five years after he published his studies of speed skaters. McKenzie wrote that the skating frieze required four years to complete and that two copies, one hundred twenty inches long and thirty-three inches high, were cast in plaster. One of these was presented to McGill University in 1936 for the Sir Arthur Currie Memorial Gymnasium and Armory and the other for the White Collection at Penn.[5]

Since 1933, reductions of this ten-foot panel have been issued. These became available as a result of an agreement between McKenzie and the Medallic Art Company to reduce the ten-foot speed skating panel to issue reductions of forty, twenty, fourteen, and four inches.[6]

A bronze copy of the ten-foot version of the *Brothers of the Wind* became available for purchase in the early 1980s. It was purchased at a Christie's fine art auction in New York in the fall of 1984 by the University of Calgary with financial assistance of the Government of Canada for a newly constructed building used for the 1988 Winter Olympic Games.[7]

It's interesting to note that in 1926, the *Intercollegiate Winter Sports Union* plaque (No. 63) was created by McKenzie through the use of a fragment of the *Brothers of the Wind* frieze. For this plaque he selected the fourth figure

from the right of the panel, the sprinting figure, for the I.W.S. Union organization, which is composed of Canadian and Northern U.S.A. universities.

Notes

1. Hussey, *Tait McKenzie*, 59.
2. "Outline for a Catalogue," ch. 10, p. 4. McKenzie Papers.
3. McKenzie had made close observations of the champions in this sport in 1893 and 1897 and at that time had published several articles on speed skating and hockey: "Hockey in Eastern Canada," *Dominion Illustrated Monthly* 2 (Feb. 1893), 56-64; "Natural Selection, as Shown in the Typical Speed Skater," *The Journal of Anatomy and Physiology* 32 (Oct. 1897), 468-76; "International Speed-Skating," *Outing* 31 (Dec. 1897), 217-20.
4. "Outline for a Catalogue," ch. 10, p. 5, McKenzie Papers.
5. *Ibid*.
6. January 1, 1933, letter of agreement between Medallic Art Company and R. Tait McKenzie and a second letter of agreement between the same parties dated March 7, 1934. McKenzie Papers.
7. Ivy, "Sculpture Underscores Art's Games Role," Calgary *Herald*, Jan. 30, 1985; and "Sculptural Relief of Speedskaters Acquired for Oval," *The University of Calgary Gazette*, v. 14, No. 24, Jan. 30, 1985.

XVII. Plunger, 1925

Swimmer preparing to dive (No. 62). Bronze, height 30 in. White Collection, UP.

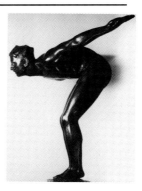

In an unpublished study of the sculptural possibilities of swimmers, McKenzie wrote:

> On the marble platform of the swimming pool the young athlete takes unconscious poses of beauty as he stands, or dives, or applies the towel after his swim. Several years ago the Intercollegiate champion diver spent the summer months with me and the 'Plunger' was the result. It shows the athlete poised, with arms ready to swing forward as he launches into a flat splashing dive that starts the race. This poised figure is familiar to every haunter of the swimming pool.[1]

Mrs. McKenzie identified Mifflin Armstrong, a Penn swimmer, as the champion who posed for this figure at her husband's summer studio by the sea at Martha's Vineyard in 1922.[2]

Plunger is one of the figures McKenzie first executed as a sketch, *Diver*, in 1911; it did not take final form until 1925. Frances Fisher Dubuc, discussing the figure for *Arts and Decoration*, expressed the feeling that "the splendid virility of the poised body . . . shows at his best the American athlete, a subject dear to the sculptor's [McKenzie's] heart." McKenzie's knowledge of anatomy had in no way interfered with the modeling of this piece, averred Dubuc.[3]

Harry J. Walker, a Canadian writer, added an interesting observation concerning the proper moment to model the figure: "In every athletic endeavor there is a moment when the direction changes radically, or a pause between two movements when the body is unconsciously poised. It may occur just before, or even after. . . . This is the 'moment' that McKenzie gets into his art. It can be seen in *The Plunger* as the diver is about to leap."[4]

Notes

1. "The Rewards of Athletics" McKenzie Papers.
2. Ethel McKenzie, notes on *Plunger*. McKenzie Papers.
3. "A Sculptor of Soldiers and Athletes," 31.
4. "The Athlete in Sculpture," 46.

XVIII. Modern Discus Thrower, 1926

Discus thrower pausing between backward and forward swings (No. 67). Bronze, height 28 in. Marked: R. Tait McKenzie, 1926. White Collection, UP.

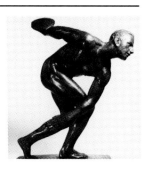

According to Christopher Hussey, *Modern Discus Thrower* "is symbolic of the revival of the Greek athletic ideal. It is the exercise most vividly associated, in most people's minds, with ancient Olympic Games, and it is commemorated in one of the most famous of Greek athletic statues—Myron's *Discobolos*."[1] In a random note, McKenzie observed that the pose of his *Modern Discus Thrower* was "taken at practically the same moment in the action of throwing the discus as that of Myron whose masterpiece has been the admiration of all art lovers."[2] Hector MacDonald of the University of Pennsylvania reportedly posed for the statuette during the summer of 1925 at Ipswich, Massachusetts.[3]

Over the years McKenzie said and wrote much concerning the technique of the discus throw. As early as 1911 he had had a chance to discuss this subject after D.A. Sargent had presented a paper on Myron's *Discobolos*, and in a lengthy dissertation McKenzie had defended the theory that the Greek athlete had used a circular movement, rather than the underhand bowling technique suggested by so many theorists, to deliver the discus.[4] Later, in 1926, the sculptor expressed the idea that his own sketch "of the Modern *Discobolos* embodies . . . the graceful and efficient practice of the art, and the lines, while differing radically from those of Myron's masterpiece, do arrange themselves in a logical and beautiful sculptured composition."[5]

Comparing McKenzie's *Discobolos* with Myron's, in itself a compliment to McKenzie, Hussey indicated that, while McKenzie's work did not equal the masterpiece in some respects, the statuette actually surpassed it in others. He believed McKenzie had created a more dynamic and subtle pose, while Myron had a "more static and plasticly defined form," giving it "permanence as work of conscious art." McKenzie's *Discobolos*, according to his biographer, had value as an athletic model with obvious sensation of force and tension.[6]

Notes

1. *Tait McKenzie*, 37.
2. "Sketches of Athletic Action," an undated, unpublished paper. McKenzie Papers.
3. Ethel McKenzie, notes on *Modern Discus Thrower*. McKenzie Papers.
4. Sargent, "Myron's Discobolos," *Fifteenth Annual Meeting of the Physical Education Directors in Colleges Minutes* (Dec. 29, 1911). McKenzie Papers.

5. McKenzie, ''The Modern Discus Thrower,'' *International Studio* 84 (May 1926), 53.
6. *Tait McKenzie*, 38, 39.

Additional References

''The Modern Discus Thrower,'' New York *Times* (May 20, 1928).
''Fine Arts Society Room, London,'' Manchester *Guardian* (June 20, 1930).
Vaughn, ''Sports Come-back in Art.''

XIX. Eight, 1930

Oarsmen carrying their shell (No. 85). Bronze, height 24 in., length 96 in., width 24 in. White Collection, UP.

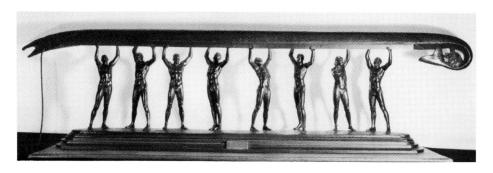

This group was initiated by the sculptor at Northeast Harbor, Maine, where he occupied a studio in August 1929. McKenzie wrote that he "worked on it until near the end of September," adding, "I think it is a very interesting composition and I am glad to say that I sold it the day before I left Northeast Harbor, although it is far from finished."[1]

Mrs. McKenzie wrote subsequently about the interest with which she and her husband watched, from the Sedgeley Club at Philadelphia's Fairmount Park, the Penn varsity crew in their early spring Saturday afternoon tryouts on the Schuylkill River. She went on to say that a member of the Penn crew had posed for this piece[2]—a statement refuted both by Carl Warton, who discussed the group in 1936, and by Christopher Hussey, who evaluated it in 1930. Warton, calling *Eight* a "large and impressive work," wrote that "seven of these figures are more or less symbolic. These are types such as you find in every college crew. One of them, however, is a sculptural portrait of Lawrence Dickey, who stroked and captained the Harvard Crew in 1930."[3]

The most complete and interesting critique of this piece was done by McKenzie's biographer; Hussey called attention to the convenient design, with the bow of the shell resembling the head of a barracuda and the stern its tail, curled around a diminutive coxswain. Most vivid and descriptive is his characterization of the oarsmen:

> Each of these on inspection, reveals a different personality, expressed in his physique and stance. Bow and stroke are typical oarsmen; in fact, the model for stroke was the stroke of last year's Harvard eight. No. 2 is a big man, over 6 ft. tall, in contrast to the broad and stocky No. 3., his short legs suggesting a powerful, if rather restricted, stroke. No.'s 4 and 5, as they should be, are heavy and strong. But No. 6., small boned and lithe, is the aristocrat type, who would give the boat the style which some of its members probably lack—notably No. 7. This man is rather fat and distinctly lazy—he is probably late on stroke and the coach is taking a big risk leaving him at No. 7 instead of bringing 4 or 5 up to this responsible place.[4]

Arthur Stanley Riggs, reviewing the Pennsylvania Academy of Fine Arts exhibition in 1931, called McKenzie's *Eight* ''a strikingly original and splendidly alive piece of plastic imagination . . . delicate and spirited in spite of its great length . . . and his realism is admirably tempered.''[5]

Notes

1. McKenzie to Max Ingres, Oct. 8, 1929. *Eight* was sold to Edward Robinette, who donated it to the Philadelphia Racquet Club. McKenzie Papers.
2. Ethel McKenzie, notes on *Eight*. McKenzie Papers.
3. Warton, ''Bronze Moments of Athletic Strain and Victory,'' Boston *Herald*, Apr. 19, 1936.
4. Hussey, ''An Eight in Bronze,'' *Country Life* (London) 68 (July 5, 1930), 21.
5. ''The Penn Academy's 126th Annual,'' *Art and Archaeology* 31 (Mar. 1931), 175, 185.

XX. Shield of Athletes, 1932

The form and characteristics of modern athletics (No. 91). Colored plaster medallion, diameter 60 in. White Collection, UP.

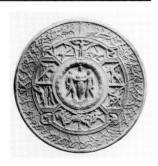

In a 1928 letter McKenzie asked a Latin professor for some words signifying strength, speed, and agility; he needed these for "a great buckler, to include the different track and field sports."[1] Mrs. McKenzie remarked that the significant idea for the piece came from the "words of Homer, telling how the god Hephaistos wrought a great shield for Achilles in his house of bronze."[2] However, McKenzie's five-foot shield was not cast in bronze; in that medium it was used in a two-inch medal for the Russian-American track meet of 1959.

Hussey described this shield prior to its being finished,[3] and McKenzie himself wrote, in 1932 and 1936, an interesting and vivid description which is worth quoting:

This great shield or buckler . . . shows the apotheosis of athletic sports on the track and field The central medallion shows the spirit of Olympia helmetted [*sic*], sandalled, and garbed in archaic Greek drapery. She brings together two modern athletes who shake hands in token of the spirit in which they will compete. Beneath their feet are the words, "Pax Olympica." This medallion is surrounded by a wreath of laurel and a border which divided it from a series of irregular shaped panels representing the field events. Beginning at the lower left hand side they show: (1) the hammer throw (2) The second panel directly above this shows three Javelin-throwers. . . . (3) The third panel of the series shows a pole vaulter. . . . (4) The fourth panel on the right of the central figure shows the high jumper Below and to the right are four shot-putters Beneath this panel, a sixth [panel] shows three men practicing the discus-throw. . . . Beneath is a long panel with eight hurdlers

An interrupted border separates these panels from the outer frieze of runners. Small square plaques divide it at the four corners each containing one figure, the two upper showing a broad-jumper . . . a high jumper . . . while the lower plaques show one athlete tying his shoe and another lifting the fifty-six pound weight.

Presiding over these panels is a winged-figure in high-relief of "Aviation" or flight, with outstretched wings; . . . in the border behind him are the words, "Fortius, altius, citius, (stronger, higher, swifter)"; while in the corresponding part of the border below is the legend, "Mens fervida in corpore lacertoso," (The eager mind in the

lithe body), chosen by Baron Pierre de Coubertin as the motto that best represents the aims of the Olympic Games.[4]

As part of the decoration of this border engraved in the background are four words representing the qualities most valuable in sport, "Aequitas" which may be translated as fair play, "Fortitudo" strength, "Agilitas" and "Celeritas" which explain themselves. In low relief are two qualities, not so important but valuable, "Accuratio" and "Elegentia."

The outer panel or frieze is occupied by a procession of runners showing the race from start to finish. The starter, the athlete resting on his mark; set, in the crouching start, and in the first strides of the race. Here, individual peculiarities are noted The race proceeds around the shield, showing every part of the stride up to the finish where we see one man fallen just short of the finish line; another with head down galloping . . . another with head climbing the ladder and two at the finish, one with arms up and the other breasting the tape with hands level with the shoulder. A two faced "Herm"[5] occupies the space between the finish and the start.[6]

This shield is executed with a high degree of relief in the central panel, and decreases in degree toward the rim. The flight figure is almost in the round. McKenzie worked on this shield for about four years and intended it as a plastic record of the form and characteristics of athletes of his time. It won the sculptor a third-prize medal in the International Olympic competition of art as related to sport.[7]

Notes

1. McKenzie to Walton Brooks McDaniel, Oct. 31, 1928. McKenzie Papers.
2. Ethel McKenzie, notes on *Olympic Shield*. McKenzie Papers.
3. *Tait McKenzie*, 48, 49.
4. Pierre de Frédy, Baron de Coubertin (1863-1937), revived the Olympic games in Greece in 1896, and was president of the International Olympic Committee from 1894 to 1925.
5. A herm is a square stone pillar supporting a bust or head, usually of the god Hermes.
6. "The Shield of the Athletes," manuscripts dated July 1932 and Dec. 1936. McKenzie Papers.
7. Elmer Dulmage, "Canadian Artist Receives Award at the Olympics," "Prize Winners in the International Olympic Competition and Exhibition of Art as Related to Sport," Edmonton *Bulletin*, Aug. 3, 1932.

XXI. Invictus, 1934

Boxer taking the count (No. 95). Bronze, height 20 in. Marked: Invictus, R. Tait McKenzie, 1934. White Collection, UP.

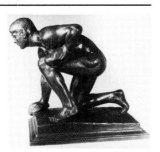

From the time McKenzie saw his first real boxing match in Calgary in 1886, he had more than a passing interest in the sport. He recorded in his notes his experience with measuring and examining John L. Sullivan for the life mask of the boxer he made in 1902;[1] a copy was reproduced for the Hutton Collection at Princeton. His 1905 sculpture *Boxer* was the only boxing piece he did for years until he completed *Invictus* in 1934. His small, rough sketch of a boxer on one knee, *Taking the Count*, was completed after *Invictus.*

The model for this figure was Joe Brown, a former professional boxer who became a successful sculptor. Indeed, it was probably Brown's influence that impelled the sculptor to model this boxer. Brown worked as an apprentice in McKenzie's Penn tower studio; together they frequented the Philadelphia boxing matches; and McKenzie accurately predicted Brown's success as a sculptor in his own right.[2]

"For many years I have been interested in the way in which the boxer saves himself to the count of nine when he has been knocked down," wrote McKenzie in his notes. "The way in which the body is supported shows that, although he is down, he is far from being out, and that his head is clearing."[3] In another article McKenzie called *Invictus* "sturdy, compact, and powerful" and added that "on his hands are the regulation four ounce boxing gloves as worn at the present time in competition."[4]

Harry Walker, a good friend who discussed McKenzie's work in a number of articles, remarked that the sculptural moment—a pause between two movements—was strikingly depicted in *Invictus.* He went on to say that "McKenzie saw this actually happen at a boxing bout, and it was vividly impressed on his mind. Accordingly he memorized the pose and worked at it afterward in clay."[5]

Notes

1. Notes for "The Measured Mile." McKenzie Papers.
2. Philadelphia *Ledger*, Apr. 15, 1934.
3. McKenzie to Healy, notes for "Sports in Art." McKenzie Papers.
4. "Some Studies in Sculpture of Athletes." McKenzie Papers.
5. Walker, "The Athlete in Sculpture," 46, 50.

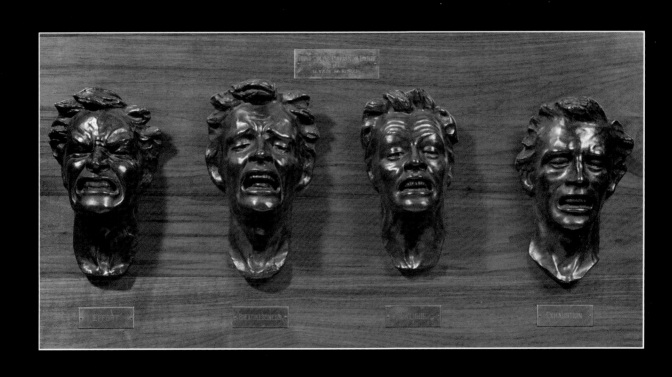

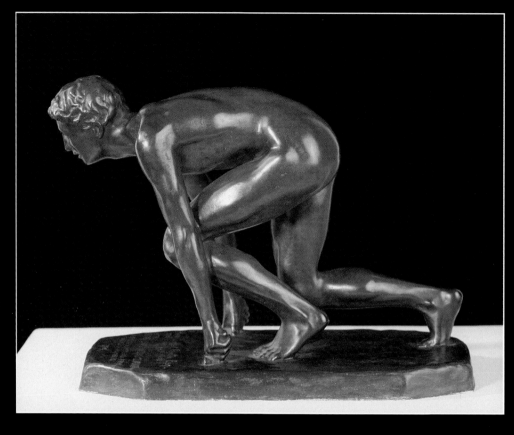

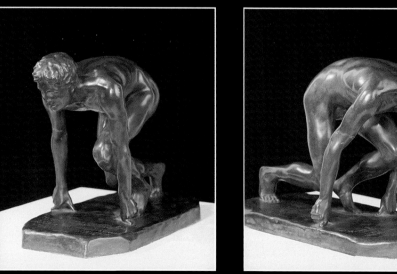

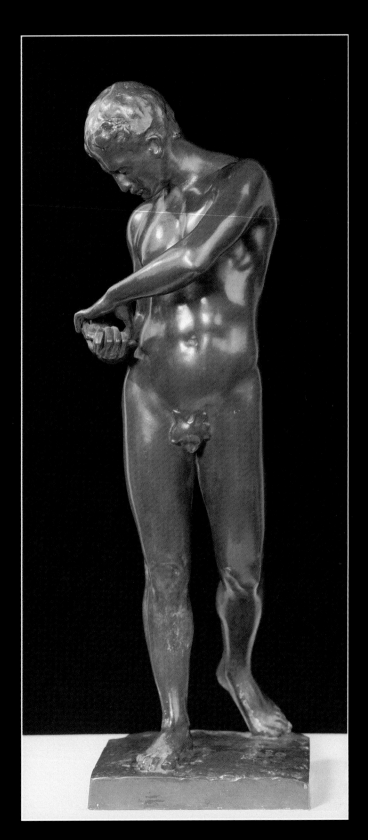
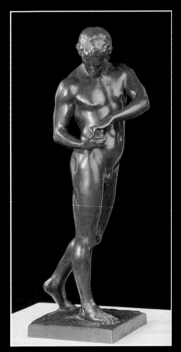
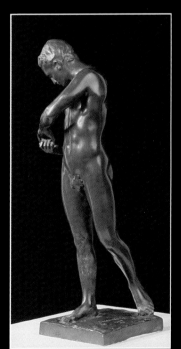

VIII *Athlete*, 1903

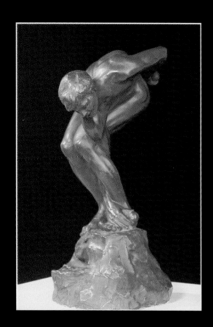

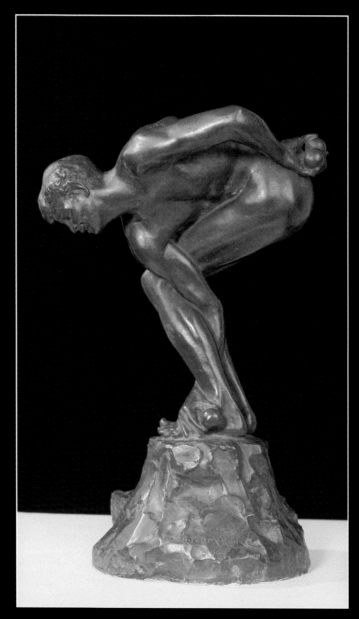

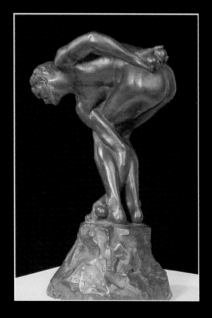

IX *Supple Juggler*, 1906

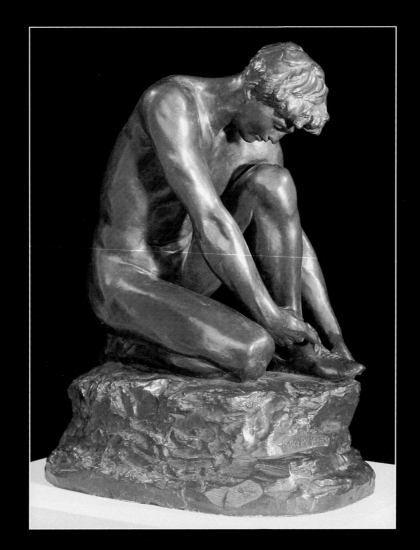

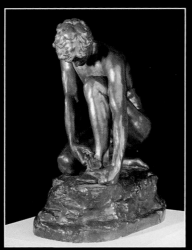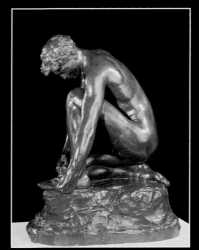

X *Competitor*, 1906

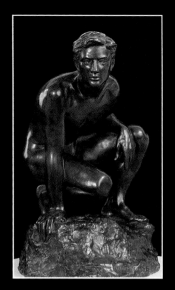
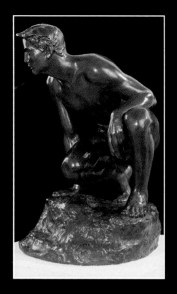
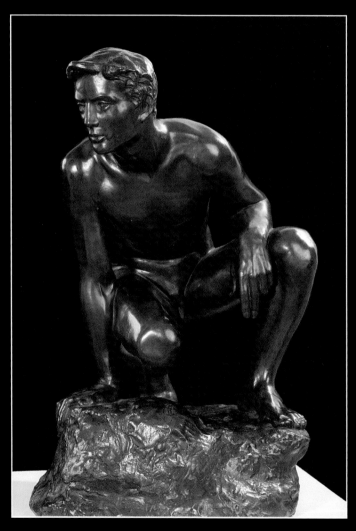

XI *Relay Runner*, 1910

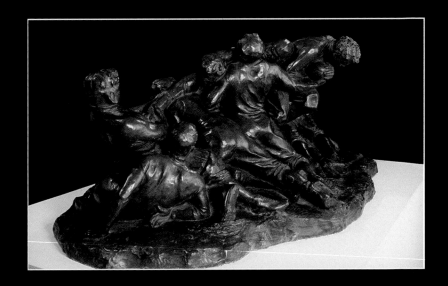

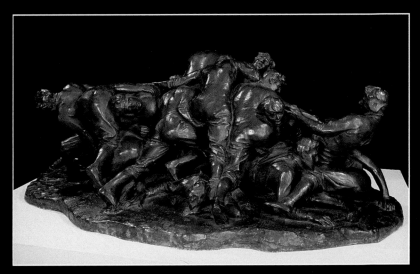

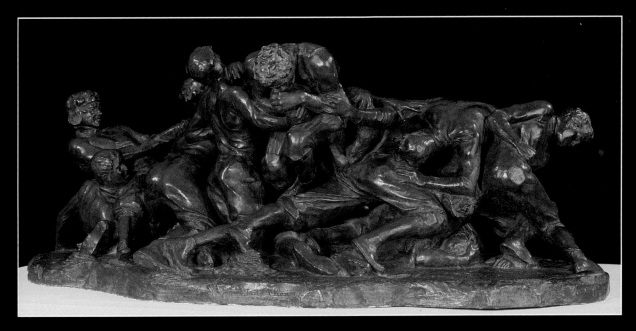

XII *Onslaught*, 1911

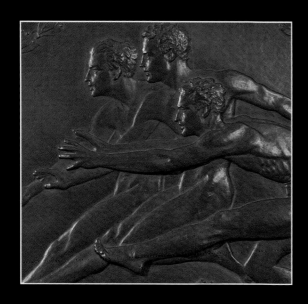

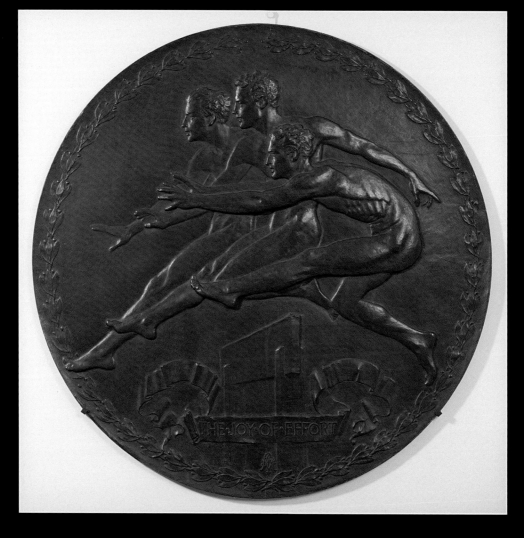

XIII *Joy of Effort*, 1912

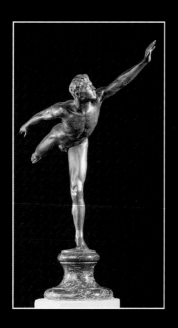
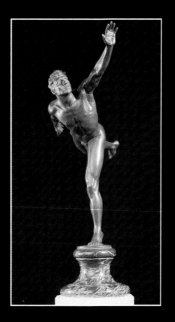
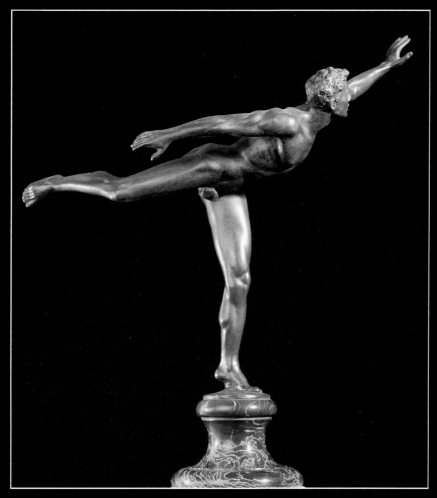

XIV *Flying Sphere*, 1920

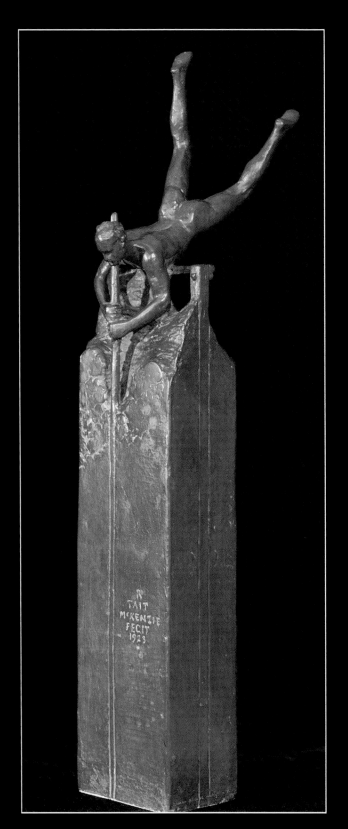
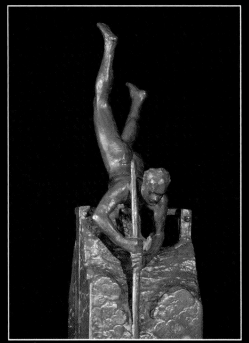
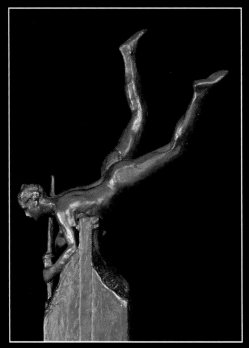

XV *Pole Vaulter*, 1923

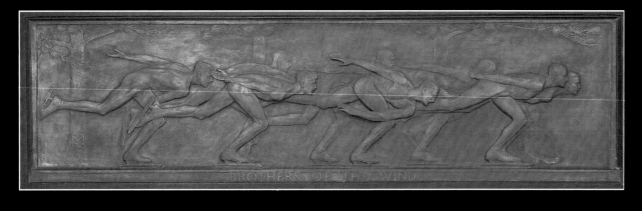

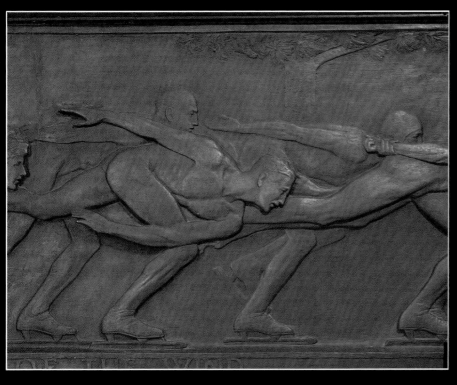

XVI *Brothers of the Wind*, 1925

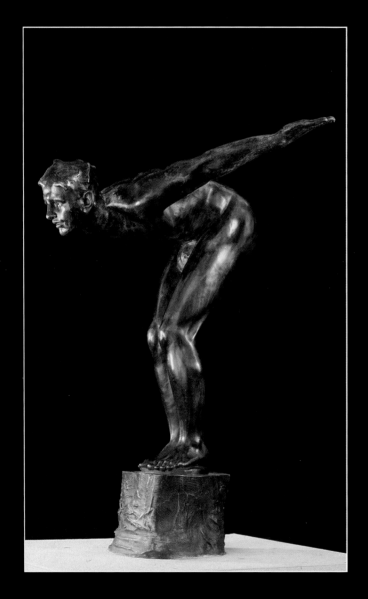

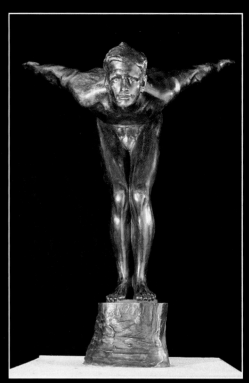

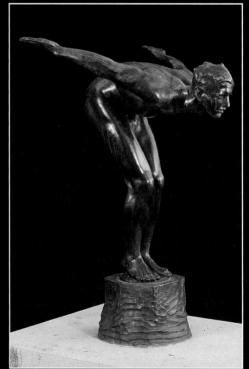

XVII *Plunger*, 1925

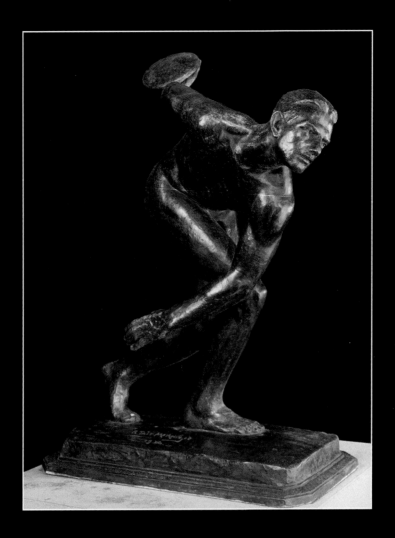

XVIII *Modern Discus Thrower*, 1926

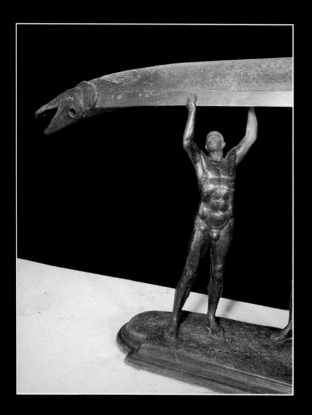
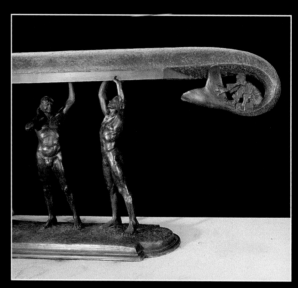
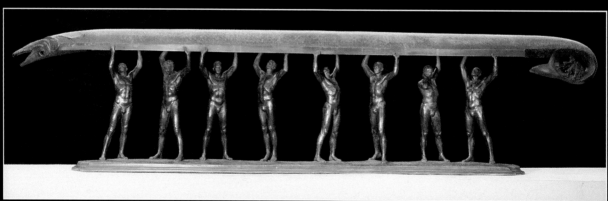

XIX *Eight*, 1930

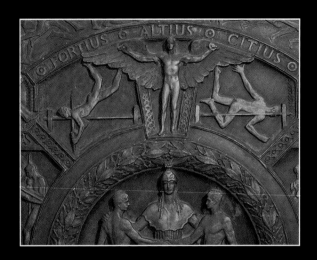

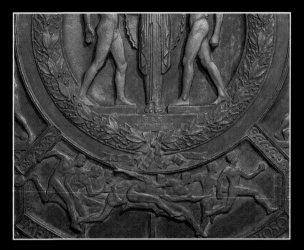

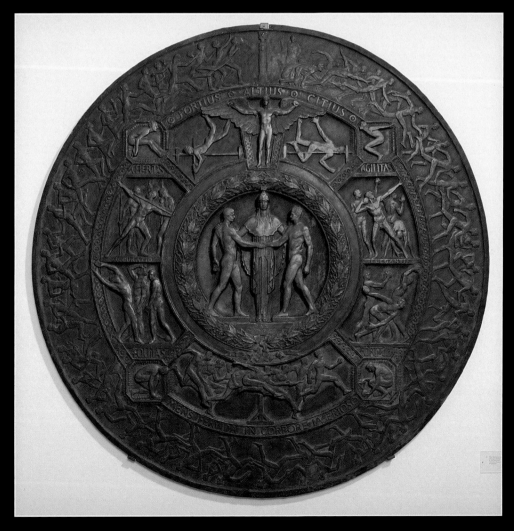

XX *Shield of Athletes*, 1932

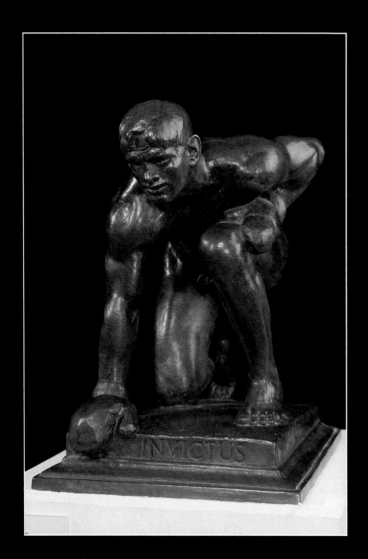

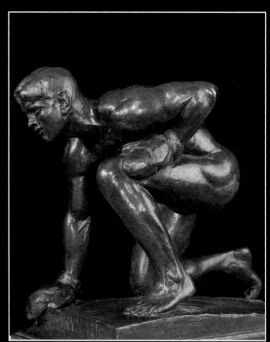

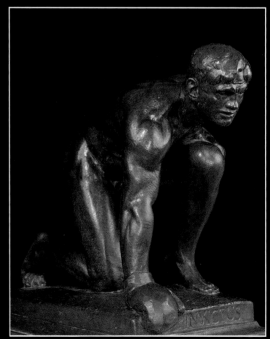

XXI *Invictus*, 1934

Catalog of Sport Sculpture

This catalog of McKenzie's sculpture of athletes is arranged chronologically, with few exceptions. McKenzie's own titles for his sculpture and information obtained from his discussion of his work have been honored. Most medals illustrated were issued in various sizes, and dimensions could not be provided in cases where pieces are missing. The collection from which each piece was photographed for this publication is indicated.

1. Skater, 1900

Plaster plaque, ht. 9 in., l. 12 in.
Mill of Kintail, Almonte, Canada

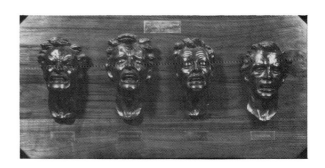

2. Masks of Facial Expression, 1902

(See also Plate VI)
Bronze, mounted on walnut, life-size
White Collection, UP

3. Sprinter, 1902

(See also Plate VII)
Bronze, ht. 9 in.
White Collection, UP

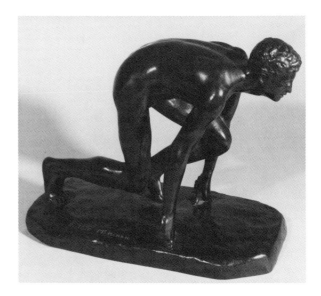

4. Athlete, 1903

(See also Plate VIII)
Bronze, ht. 16 in.
White Collection, UP

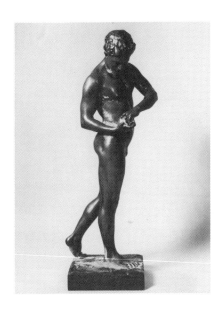

5. Boxer, 1905

Bronze, ht. 18 in.
White Collection, UP

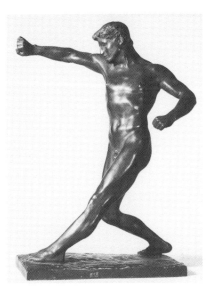

6. Discobolos No. 1, 1905

Colored plaster plaque, ht. 4 in., l. 7 in.
Wolffe Collection, UTK

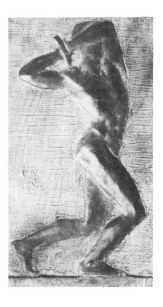

7. Discobolos No. 2, 1905

Colored plaster plaque, ht. 4 in., l. 7 in.
Wolffe Collection, UTK

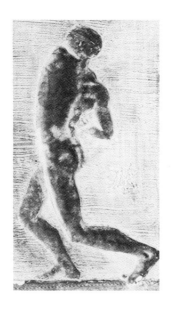

8. Discobolos, 1906

Plaster medal, size unknown
Photograph, McKenzie Papers

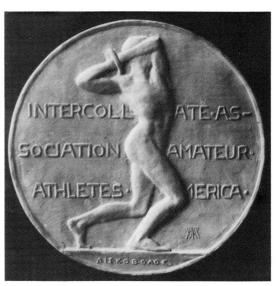

9. Supple Juggler, 1906

(See also Plate IX)
Bronze, ht. 14 in.
White Collection, UP

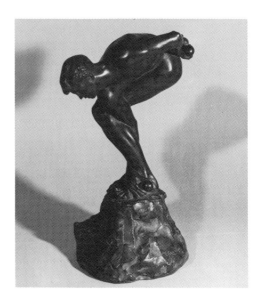

10. Competitor, 1906

(See also Plate X)
Bronze, ht. 21 in.
White Collection, UP

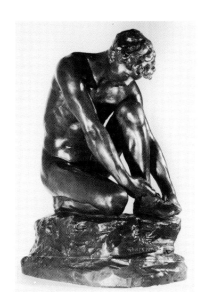

**11. New York Public School
Athletic League, 1906**

Bronze medal, diam. 1-1/4 in.
Wolffe Collection, UTK

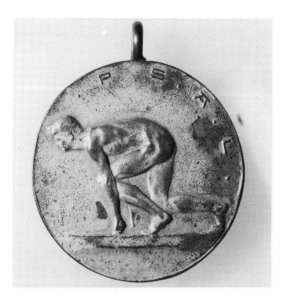

12. Relay Runner, 1910

(See also Plate XI)
Bronze, ht. 22 in.
White Collection, UP

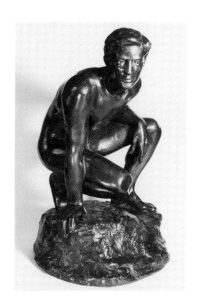

13. Onslaught, 1911

(See also Plate XII)
Bronze, ht. 15 in., l. 36 in., w. 21 in.
White Collection, UP

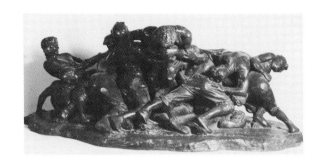

14. Diver, 1911

Bronze sketch, ht. 10 in.
White Collection, UP

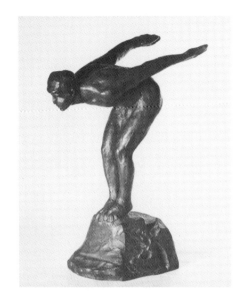

15. Discobolos, Forward Swing, 1911

Plaster sketch, ht. 10 in.
Photograph, McKenzie Papers

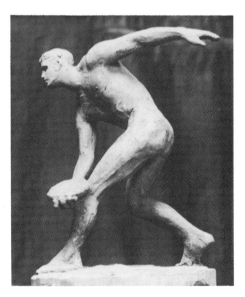

16. Shot Putter, Preparing, 1911
Bronze sketch, ht. 10 in.
Wolffe Collection, UTK

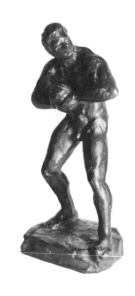

17. Shot Putter, Ready, 1911
Bronze sketch, ht. 10 in.
White Collection, UP

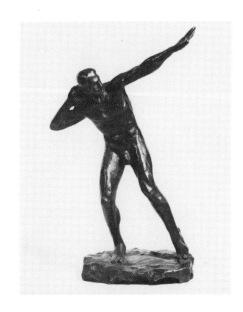

18. High Jumper Cleaning Shoe, 1911
Plaster sketch, ht. 10 in.
White Collection, UP

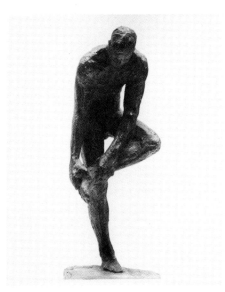

19. High Jumper Cleaning Shoe, undated

Bronze sketch, ht. 10 in.
Wolffe Collection, UTK

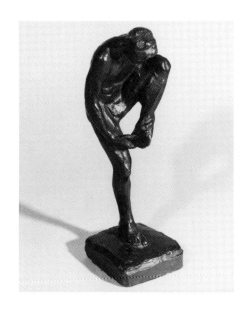

20. Wounded, 1911

Bronze sketch, ht. 6 in.
Wolffe Collection, UTK

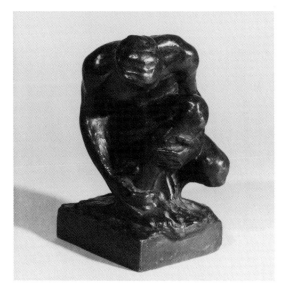

21. Tackle, 1911

Bronze sketch, ht. 4 in.
White Collection, UP

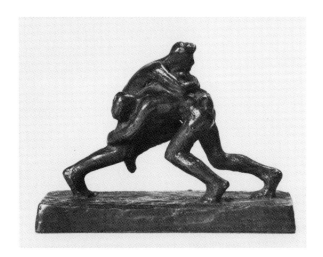

22. Relay No. 1, 1911

Bronze sketch, ht. 9 in.
Wolffe Collection, UTK

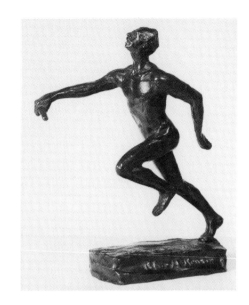

23. Relay No. 2, 1911

Bronze sketch, ht. 9 in.
White Collection, UP

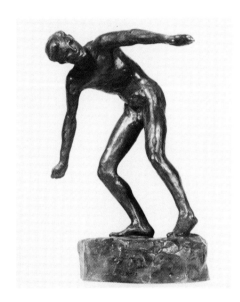

**24. They Are Swifter than Eagles
(restudy of New York Public School Ath-
letic League medal), 1912**

Plaster medal, size unknown
Photograph, McKenzie Papers

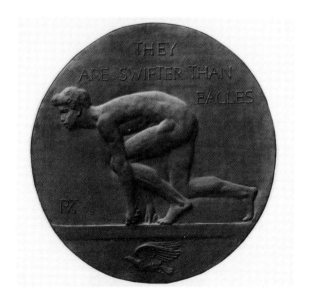

25. Joy of Effort, 1912
(See also Plate XIII)
Bronze medallion, diam. 46 in.
White Collection, UP

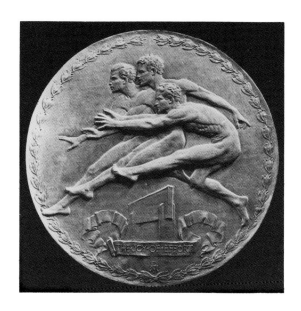

26. Playground and Recreation Association, 1912
Bronze medal, diam. 1 in.
Wolffe Collection, UTK

27. Playground and Recreation Association, 1912
Bronze medal, diam. 1 in.
Wolffe Collection, UTK

**28. Playground and Recreation
Association, 1912**

Plaster medallion, diam. 10 in.
Photograph, McKenzie Papers

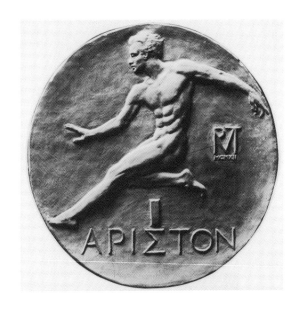

29. "W" (University of Wisconsin), 1913

Bronze plaque, ht. 9 in. l. 5 in.
White Collection, UP

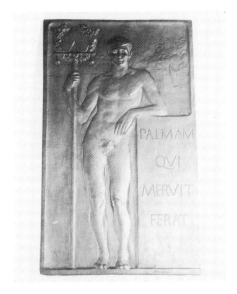

30. "W" (University of Wisconsin), 1913

Bronze medal, ht. 2 in., l. 1 in.
White Collection, UP

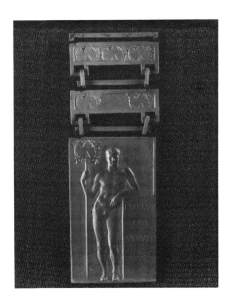

31. Fencers Club of Philadelphia, 1914

Bronze medallion, diam. 7 in.
White Collection, UP

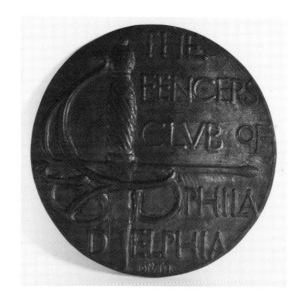

32. Joy of Effort (altered), 1914

Bronze medal, diam. 3 in.
Wolffe Collection, UTK

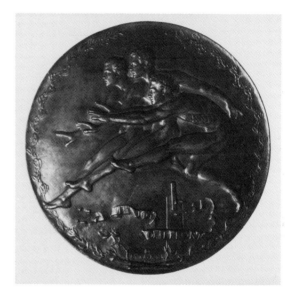

33. ICAA Scholarship, 1916

Bronze medal, diam. 3 in.
White Collection, UP

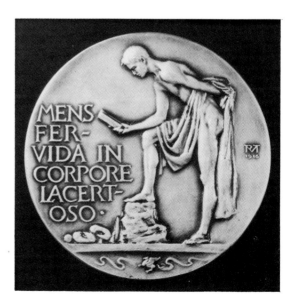

34. ICAA Track and Field, 1917

Bronze medallion, diam. 8 in.
White Collection, UP

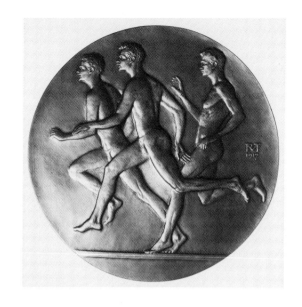

35. ICAA, 1916-24

Bronze medal (reverse)
Photograph, H.O. Crisler,
University of Michigan

36. ICAA (redesigned), 1925

Bronze medal (reverse)
Photograph, McKenzie Papers

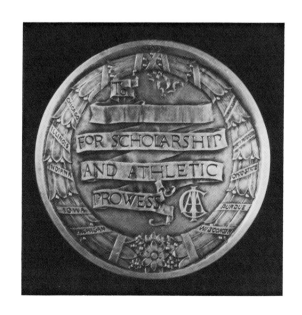

37. Watching the Pole Vault, 1921

Plaster sketch, ht. 10 in.
White Collection, UP

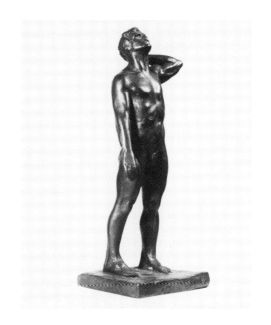

38. Shot Putter, Resting, 1919

Bronze sketch, ht. 10 in
Wolffe Collection, UTK

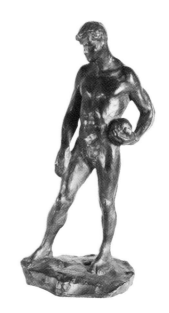

39. Winded, 1919

Bronze sketch, ht. 9 in.
Wolffe Collection, UTK

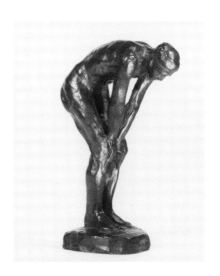

40. Acrobat (doorknocker), 1919

Bronze sketch, ht. 8 in.
Hussey photograph, *Tait McKenzie*

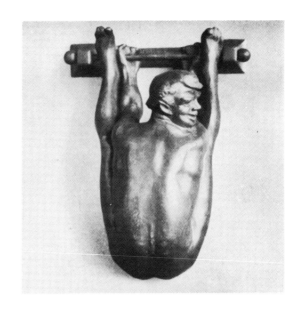

41. Backstand (candlesticks), 1919

Silver-plated sketch, 12 in.
Elizabeth Pitt Barron,
Niagara Falls, Ontario, Canada

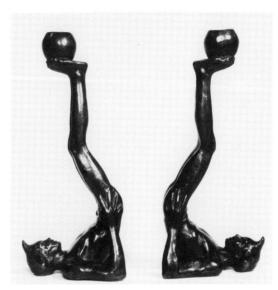

42. Flying Sphere, 1920

(see also Plate XIV)
Bronze, ht. 18 in.
White Collection, UP

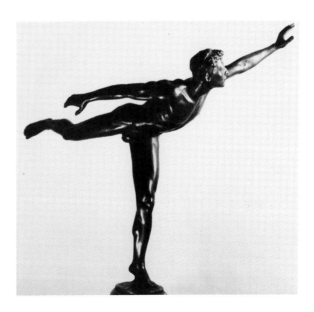

43. Achilles Club, 1921

Bronze medal, diam. 3 in.
Photograph, McKenzie Papers

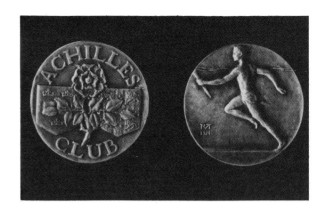

**44-45. Acrobat, Prone Arch Back
and Acrobat, Supine Curl, Legs Crossed
(knife rests), 1922**

Plaster sketches, size unknown
Hussey photograph, *Tait McKenzie*

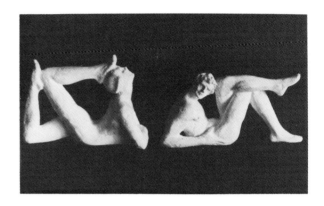

46. Knee Touch (paper knife), 1922

Plaster sketch, size unknown
Photograph, McKenzie Papers

47. Javelin Cast, 1923

Bronze, ht. 18 in.
White Collection, UP

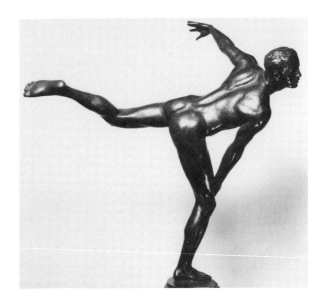

48. Pole Vaulter, 1923

(See also Plate XV)
Bronze, ht. 18 in.
White Collection, UP

49. Modern Discus Thrower, 1923

Plaster sketch, ht. 6-1/2 in.
White Collection, UP

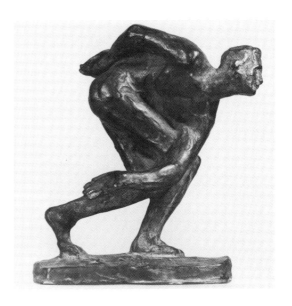

**50. Grotesque, Why Not No. 1
(Shot-putter), 1923**

Bronze, ht. 10 in.
Wolffe Collection, UTK

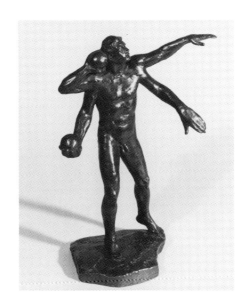

**51. Grotesque, Why Not No. 2
(Boxer), 1923**

Bronze, ht. 10 in.
Wolffe Collection, UTK

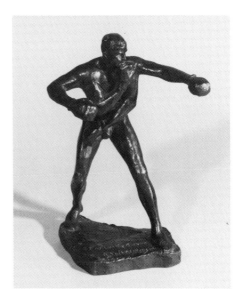

52. Pennsylvania Relay Carnival, 1925

Plaster medallion, diam. 18 in.
Photograph, McKenzie Papers

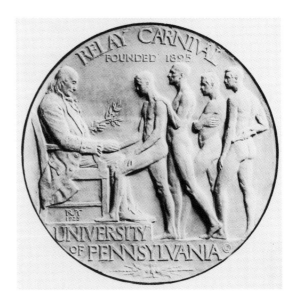

53. Ice Bird, 1925

Bronze, ht. 26 in.
White Collection, UP

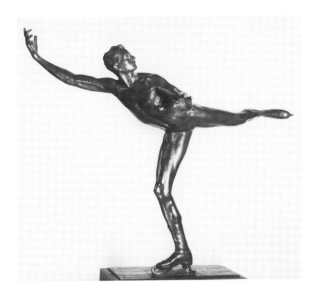

54. Brothers of the Wind, 1925

(See also Plate XVI)
Colored plaster, ht. 33 in., l. 120 in.
White Collection, UP

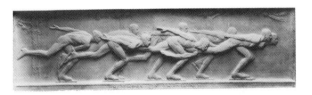

55. Diving, 1925

Plaster medal sketch, diam. 5 in.
UP Archives, McKenzie Papers

56. Swimming, 1925

Plaster medal sketch, diam. 4-1/2 in.
UP Archives, McKenzie Papers

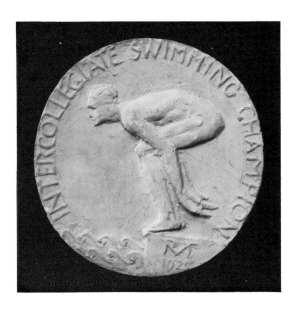

57. Swimming, 1925

Plaster medal sketch, diam. 4 in.
UP Archives, McKenzie Papers

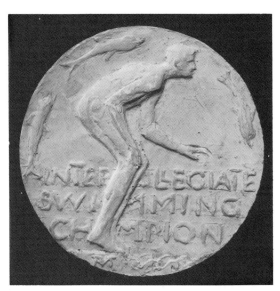

58. ICAA Tennis, 1925

Plaster medal sketch, diam. 5 in.
White Collection, UP

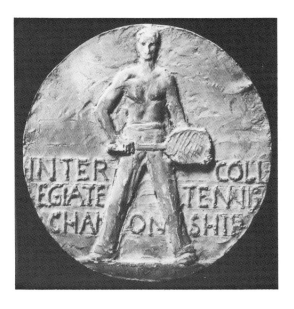

59. ICAA Tennis, 1925

Plaster medal sketch, diam. 5 in.
White Collection, UP

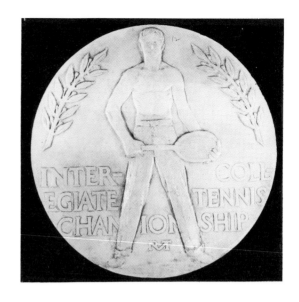

60. ICAA Tennis, 1925

Plaster medal sketch, diam. 5 in.
White Collection, UP

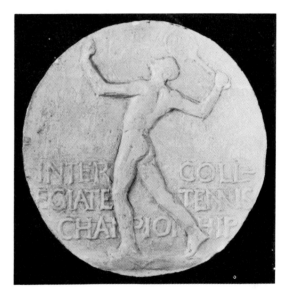

61. ICAA Tennis, 1925

Plaster medal sketch, diam. 5 in.
White Collection, UP

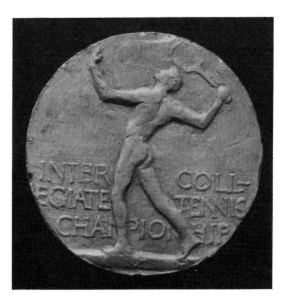

62. Plunger, 1925

(See also Plate XVII)
Bronze, ht. 30 in.
White Collection, UP

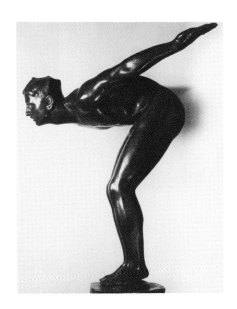

**63. Intercollegiate Winter Sports
Union, 1926**

Bronze plaque, ht. 6 in., l. 9 in.
White Collection, UP

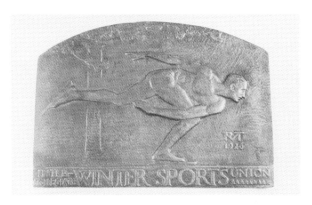

**64. Athletic Sports Sesquicentennial—
Philadelphia, 1926**

Plaster medallion, diam. 14 in.
Photograph, McKenzie Papers

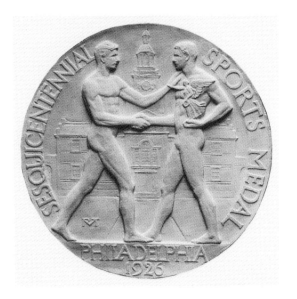

65. Champion, 1926

Bronze, ht. 10 in.
White Collection, UP

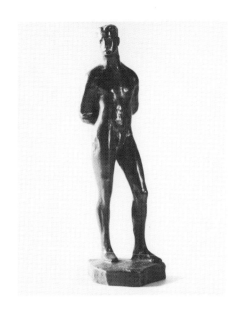

66. Percy D. Haughton, 1926

Colored plaster portrait, ht. 44 in., l. 20 in.
White Collection, UP

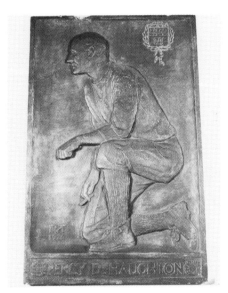

67. Modern Discus Thrower, 1926

(See also Plate XVIII)
Bronze, ht. 28 in.
White Collection, UP

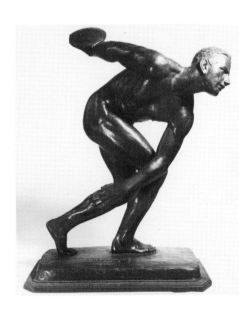

68. Line Play (Percy D. Haughton Memorial), 1927

Colored plaster, ht. 26 in., l. 60 in.
White Collection, UP

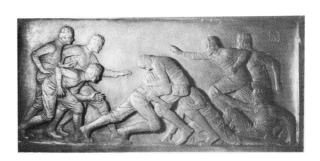

69. Punt (Percy D. Haughton Memorial), 1927

Colored plaster, ht. 26 in., l. 60 in.
White Collection, UP

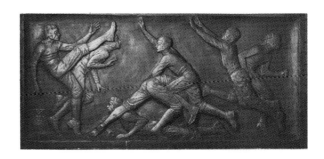

70. Upright Discus Thrower, 1928

Bronze, ht. 10 in.
Wolffe Collection, UTK

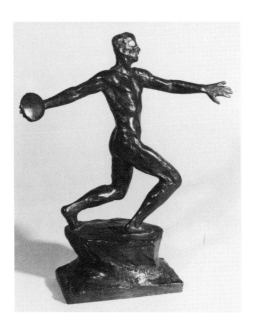

71. Lenape (doorknocker), 1928

Bronze sketch, size unknown
Lenape Club, Faculty Club, UP

72. Shield of Athletes, 1928

Colored plaster medallion, diam. 60 in.
Hussey photograph, *Tait McKenzie*

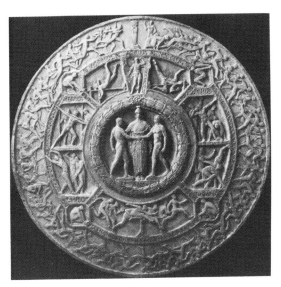

73. Shot Putter, Hop, 1928

Bronze, ht. 10 in.
Wolffe Collection, UTK

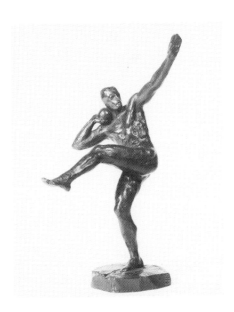

74. Winner, 1928

Bronze sketch, ht. 12 in.
Wolffe Collection, UTK

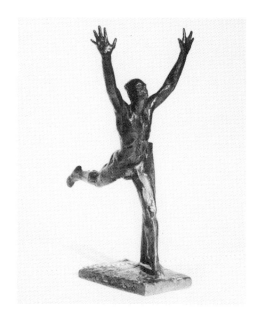

75. Lord Burghley, 1928

Plaster plaque, ht. 32 in., l. 40 in.
Hussey photograph, *Tait McKenzie*

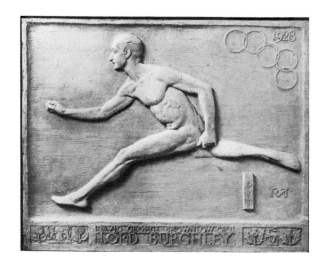

**76. Grotesque Contortionist
(knife rest), 1929**

Bronze sketch, size unknown
Photograph, McKenzie Papers

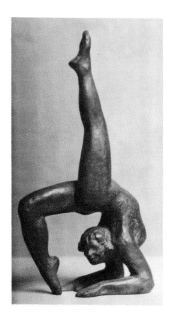

77. ICAA Tennis, 1929

Bronze medallion, diam. 11-5/8 in.
Wolffe Collection, UTK

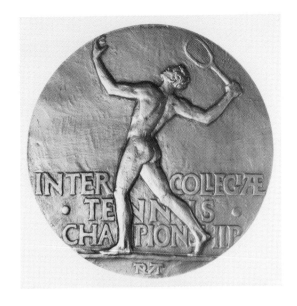

78. ICAA Swimming, 1929

Bronze medallion, diam. 10-3/4 in.
Wolffe Collection, UTK

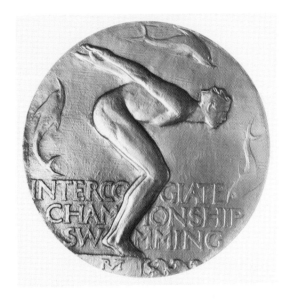

79. ICAA Wrestling, 1929

Bronze medallion, diam. 11 in.
Wolffe Collection, UTK

80. ICAA Gymnastics, 1929

Bronze medallion, diam. 12 in.
Wolffe Collection, UTK

81. ICAA Fencing, 1929

Bronze medallion, diam. 11-1/2 in.
Wolffe Collection, UTK

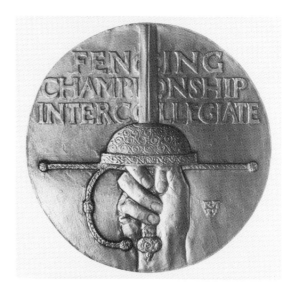

82. ICAA Golf, 1929

Bronze medallion, diam. 11-1/4 in.
Wolffe Collection, UTK

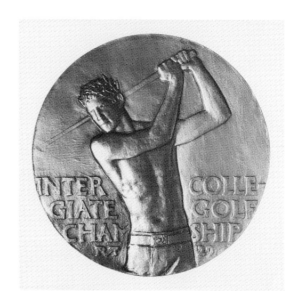

83. ICAA Fencing (rejected), 1929

Plaster medallion, diam. 11-1/2 in.
Photograph, McKenzie Papers

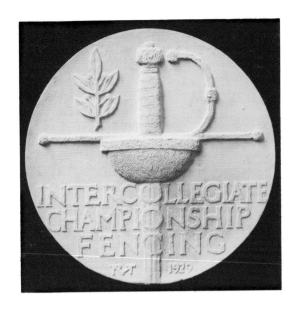

84. Double Tackle, 1929

Bronze sketch, ht. 4 in.
White Collection, UP

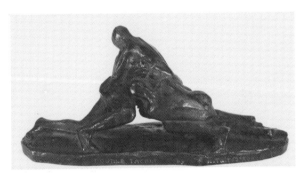

85. Eight, 1930

(See also Plate XIX)
Bronze, ht. 24 in., l. 96 in., w. 24 in.
White Collection, UP

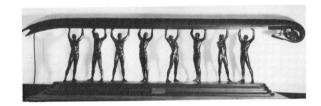

86. James E. Sullivan (AAU), 1930
Bronze medal, diam. 5 in.
White Collection, UP

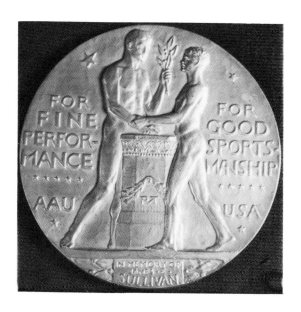

87. James E. Sullivan (AAU), undated
Plaster medal sketch, diam. 5 in.
UP Archives, McKenzie Papers

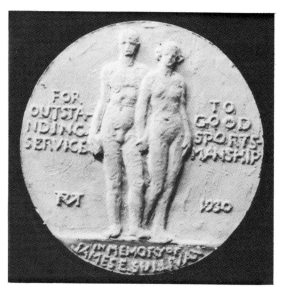

88. James E. Sullivan (AAU), undated
Plaster medal sketch, diam. 5 in.
UP Archives, McKenzie Papers

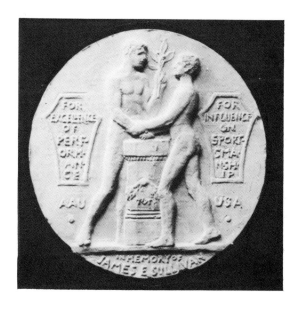

89. James E. Sullivan (AAU), 1930

Plaster medal sketch, diam. 5 in.
UP Archives, McKenzie Papers

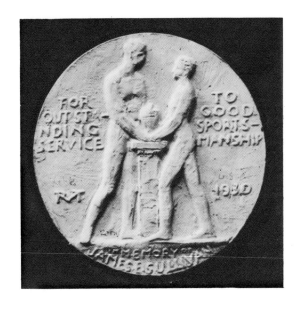

90. James E. Sullivan (AAU), 1931

Bronze medal, diam. 5 in.
White Collection, UP

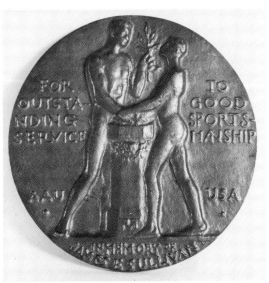

91. Shield of Athletes, 1932

(See also Plate XX)
Colored plaster medallion, diam. 60 in.
White Collection, UP

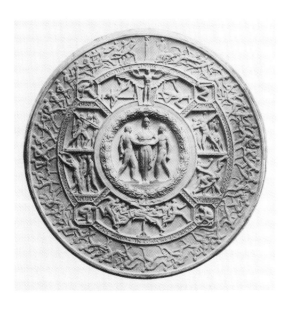

92. William A. Carr, 1932

Bronze portrait sketch, ht. 10 in.
Wolffe Collection, UTK

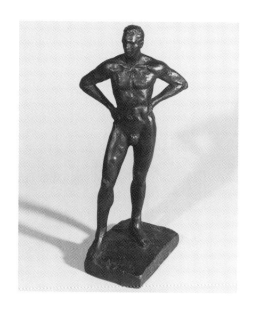

93. William A. Carr, Stride, 1932

Bronze portrait sketch, ht. 10 in.
Wolffe Collection, UTK

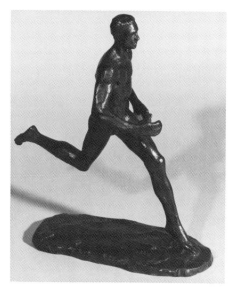

94. Three Punters, 1932-33

Bronze medallion, diam. 46 in.
White Collection, UP

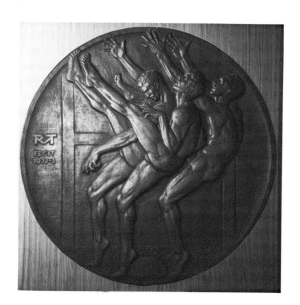

95. Invictus, 1934

(See also Plate XXI)
Bronze, ht. 20 in.
White Collection, UP

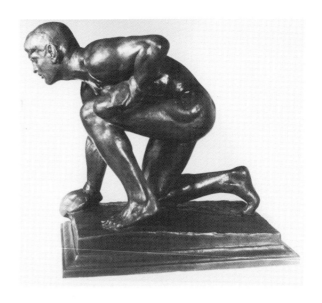

96. Passing the Baton, 1934

Plaster plaque, ht. 15 in., l. 50 in.
White Collection, UP

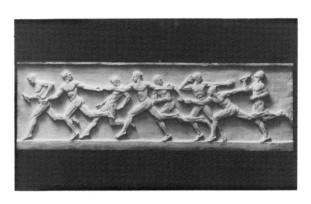

97. Back Outside Loop, 1934

Bronze, ht. 10 in.
White Collection, UP

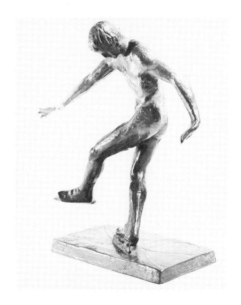

98. Prone Backbend Grotesque, 1936
Bronze sketch, ht. about 4 in.
Hussey photograph, *Tait McKenzie*

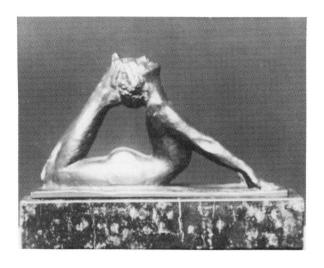

99. Modified Headstand Grotesque, 1936
Bronze sketch, ht. about 4 in.
Hussey photograph, *Tait McKenzie*

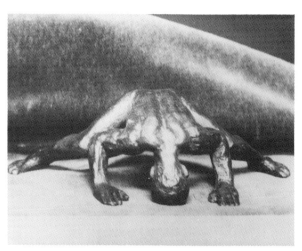

100. Supine Backbend Grotesque, 1936
Bronze sketch, ht. about 4 in.
Photograph, McKenzie Papers

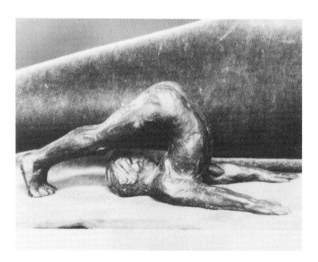

101. Frog Sit Grotesque, 1936
Bronze sketch, ht. about 4 in.
Photograph, McKenzie Papers

102. Taking the Count, 1936
Plaster sketch, ht. 4-1/2 in.
White Collection, UP

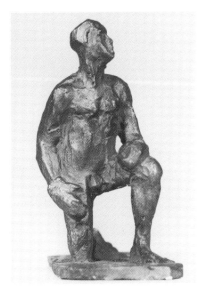

103. Jesse Owens, Broad Jumper, 1936
Colored plaster, ht. 9 in.
Photograph, McKenzie Papers

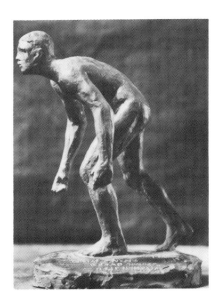

104. Robert Henry Michelet, 1936
Colored plaster, ht. 38 in.
Photograph, McKenzie Papers

105. Javelin Cast, 1936
Plaster medallion, diam. 10 in.
White Collection, UP

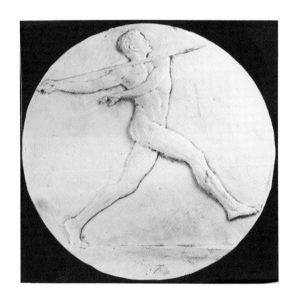

106. Strength and Speed, 1936
Bronze medal, diam. 3 in.
Wolffe Collection, UTK

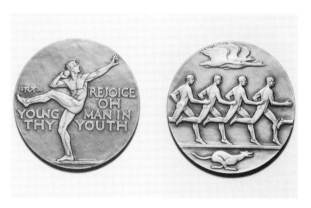

107. Viro non Victori, 1936

Colored plaster sketch, diam. 12 in.
White Collection, UP

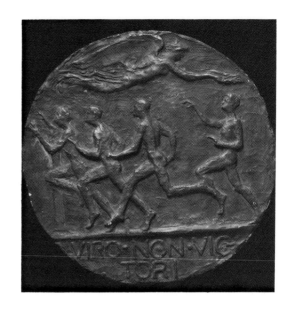

108. Safe at First, 1936

Plaster sketch, ht. 3 in.
White Collection, UP

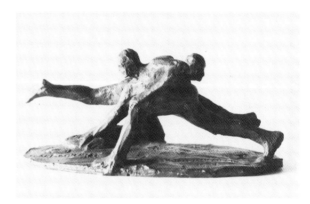

109. New York Skaters Club, 1936

Bronze medal, diam. 5 in.
White Collection, UP

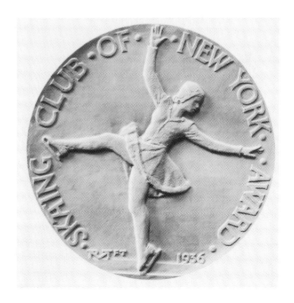

110. New York Skaters Club, 1936

Plaster medal sketch, diam. 4-3/4 in.
UP Archives, McKenzie Papers

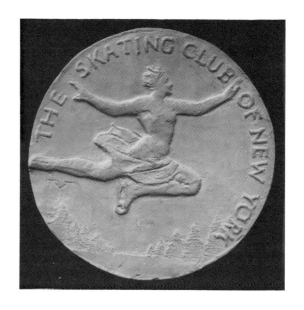

111. New York Skaters Club, 1936

Plaster medal sketch, diam. 5 in.
UP Archives, McKenzie Papers

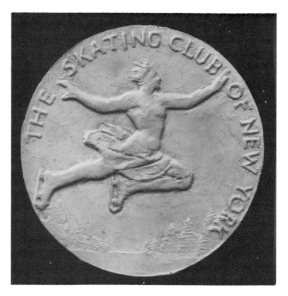

112. New York Skaters Club, 1936

Plaster medal sketch, diam. 5-3/4 in.
UP Archives, McKenzie Papers

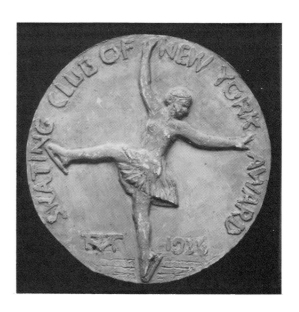

113. New York Skaters Club, undated

Plaster medal sketch, diam. 4-1/4 in.
UP Archives, McKenzie Papers

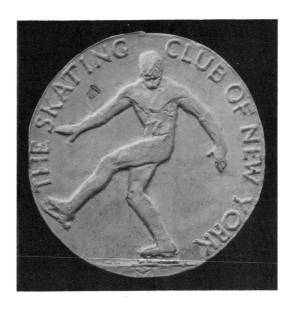

114. Baseball Pitcher, 1936

Plaster medal sketch, diam. 4-1/2 in.
UP Archives, McKenzie Papers

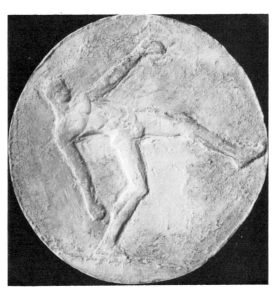

115. Rower, c 1936

Colored plaster sketch, diam. 4-1/2 in.
White Collection, UP

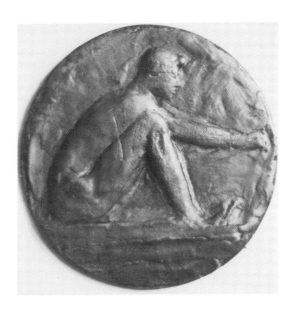

116. Vaulter, 1936

Plaster medal sketch, diam. 4-1/2 in.
UP Archives, McKenzie Papers

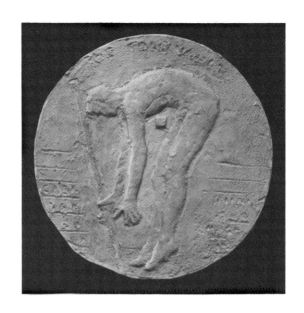

117. Wrestlers, 1936

Plaster medal sketch, ht. 3-1/4 in.,
l. 2-1/4 in.
UP Archives, McKenzie Papers

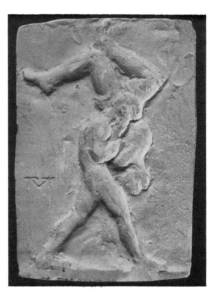

118. Girl Discobolus, 1936

Plaster medal sketch, diam. 5 in.
UP Archives, McKenzie Papers

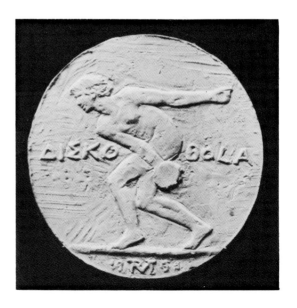

119. William A. Carr, 1936
Plaster portrait, ht. 36 in.
Photograph, McKenzie Papers

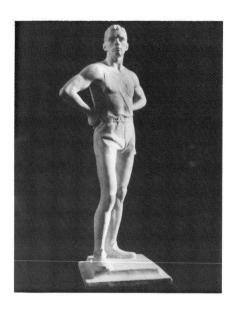

120. Wrestling Group, 1937
Bronze, ht. 10 in.
UP Archives, McKenzie Papers

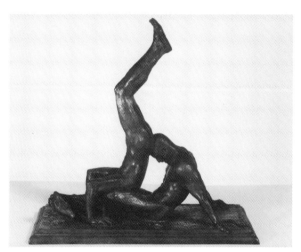

121. Boxers, 1937
Plaster medal sketch, diam. 4-3/4 in.
UP Archives, McKenzie Papers

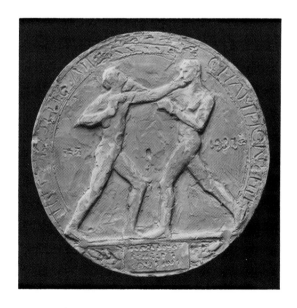

122. Golfer, 1937

Plaster medal sketch, diam. 4-3/4 in.
UP Archives, McKenzie Papers

123. Football Runner, 1937

Plaster medal sketch, diam. 4-1/2 in.
UP Archives, McKenzie Papers

124. Pratt (Amherst), 1937

Plaster medal, diam. 8 in.
Photograph, McKenzie Papers

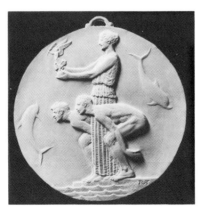

125. Duke Kahanamoku, 1937
Plaster sketch, ht. 12 in.
White Collection, UP

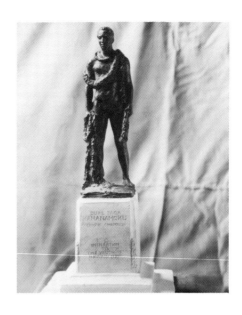

126. Lord Burghley, 1938
Plaster, ht. 32 in., l. 40 in.
White Collection, UP

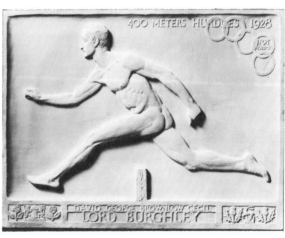

Life Chronology

1867 Born in Almonte, Ontario, Canada, May 26, son of the Reverend William and Catherine (Shiells) McKenzie

1884 Attended Ottawa Collegiate Institute

1885–89 McGill University, A.B. degree

1889–92 McGill University, M.D. degree

1893 House surgeon, Montreal General Hospital

 Ship's surgeon, Beaver Line Steamer, Liverpool to Montreal

1894–95 Assistant demonstrator of anatomy, McGill University

1895 House physician to John Campbell Gordon, Lord Aberdeen, governor-general of Canada

1896–1904 Medical director of physical training, McGill University

1899 Cofounder, Collegiate Society of Gymnasium Directors

1899–1903 Lecturer, artistic anatomy, Montreal Art Association

1900 Elected president, Society of Directors of Physical Education in Colleges

1900–01 Lecturer in Department of Physical Education, Harvard University Summer School

1904 Lecturer and senior demonstrator of anatomy, McGill University

 Lecturer, Olympic Course, Louisiana Purchase Exposition, St. Louis; silver medal award

 Professor of Physical Education and director of department, University of Pennsylvania

 Elected president, Society of Directors of Physical Education in Colleges

1905 Elected to the College of Physicians of Philadelphia

1907 Married Ethel O'Neil, daughter of John O'Neil, Hamilton, Ontario, in Chapel Royal, Dublin

 Appointed professor of physical therapy, University of Pennsylvania

 Certificate as honorary graduate of Harvard Summer School for Physical Education

1909	Elected president, Society of Directors of Physical Education in Colleges
	First book, *Exercise in Education and Medicine*, published by W.B. Saunders Company, Philadelphia
1912	Elected president, Society of Directors of Physical Education in Colleges
1912–15	Elected president, American Physical Education Association
1914	Awarded King's Medal by Gustavus V of Sweden for sculpture at 1912 Olympic Games
	Awarded M.P.E. degree, Springfield College
1915	Inspector of physical training and medical officer in charge of Heaton Park, Manchester, England
	Major (temporary), Royal Army Medical Corps, England
	Awarded honorable mention by Art Board of the Panama-Pacific International Exposition, San Francisco, for *Young Franklin*
1917	Edited the first of a series of books for Lea & Febiger in the field of physical education. *Applied Anatomy and Kinesiology*, by Wilbur P. Bowen
	Appointed inspector of convalescent hospitals in the Canadian military service
1918	*Reclaiming the Maimed*, a handbook of physical therapy published by Macmillan Company
1921	Awarded LL.D. degree, McGill University
	Appointed chairman of Intercollegiate Boxing Association
1922	Appointed to Art Club of Philadelphia
	Invited to become honorary member of Athenaeum Club, London
	Elected to National Sculpture Society
1923	Elected president, Contemporary Club
1926	Cofounder, American Academy of Physical Education (chartered, 1930); elected president each year until his death
1928	Awarded A.E.D. (Doctor of Fine Arts), University of Pennsylvania Member, first board of directors, The Fencers Club of Philadelphia
	Elected Honorary Fellow of the Royal Canadian Academy
	Awarded gold medal of St. Andrews Society of Philadelphia
1929	Elected honorary, nonresident member of Royal Academy of Arts
1931	Appointed J. William White Research Professor of Physical Education, University of Pennsylvania

1932 Awarded bronze medal for *Shield of Athletes*, Olympic Art Competition, Los Angeles

Presented the Eleventh Nathan Lewis Hatfield Lecture, College of Physicians, Philadelphia

1933 Awarded Trimble Medal by the Medical and Chirurgical Faculty of the State of Maryland, Baltimore

1934 Awarded degree of Fellow of the Academy of Physical Medicine

1935 Awarded the Silver Buffalo for Distinguished Service to Boyhood by the Boy Scouts of America

1936 Olympic Fine Arts Committee; chairman of the sculpture committee for the 1936 Olympiad in Berlin

1936–38 Vice-president of the New York Folk Arts Center (chartered, 1936); served until his death

1937 Professor emeritus, University of Pennsylvania

Elected president of the American Academy of Physical Medicine

1938 Died April 28, in Philadelphia

Exhibitions

This list does not pretend to be all-inclusive but does represent rather extensive research and approaches being nearly complete.

1900 Ottawa: National Gallery, Royal Canadian Academy of Arts
Montreal: Art Gallery, Phillips Square, Art Association of Montreal

1901 Montreal: Art Gallery, Phillips Square, Art Association of Montreal

1902 New York: Galleries of the American Fine Arts Society, Society of American Fine Artists

Boston: Copley Society exhibition

Montreal: Sherbrooke Studios

1903 Ottawa: National Gallery, Royal Canadian Academy of Arts

London: Royal Academy of Arts

Paris: Salon

1904 London: Royal Academy of Arts

Paris: Salon

1905 Portland, Oregon: Department of Fine Arts, Lewis and Clark Centennial Exposition

1906 New York: Galleries of the American Fine Arts Society

Boston: Gallery of Doll and Richards, Sculpture by Dr. R. Tait McKenzie

New York: National Academy of Design

Philadelphia: Academy of the Fine Arts

1907 Paris: Salon

London: Royal Academy of Arts

1908 New York: Gallery of Fishel, Adler and Schwartz

Philadelphia: McClees Galleries, exhibition with Eugene Paul Ullman

Pittsburgh: Gallery of Wunderly Brothers, exhibition with Eugene Paul Ullman

Montreal: Montreal Art Association Gallery

London: Royal Academy of Arts

Indianapolis: John Herron Art Institute, Art Association of Indianapolis, A Special Collection of Statuettes and Bas-Reliefs in Bronze, by R. Tait McKenzie

1909 Paris: Salon

1910 Brussels: International Exposition

Buenos Aires: International Exposition

1911 Rome: Roman Art Exposition, United States Pavilion

Philadelphia: Academy of the Fine Arts

Liverpool: Walker Art Gallery

1912 Philadelphia: Academy of the Fine Arts

Stockholm: Olympic Competition and Art Exhibition, 5th Olympiad

New York: Montross Gallery, exhibition of sculpture with Paul Bartlett and 22 other artists

London: Royal Academy of Arts

1913 Philadelphia: McClees Galleries, and Montreal: Montreal Art Association, The Work of Ten Years in Sculpture, Chronologically Arranged including Figures in the Round, High and Low Reliefs, Medals and Portrait Plaques by Dr. R. Tait McKenzie, 1902-1912

Buffalo: Albright Art Gallery

1915 San Francisco: Panama-Pacific International Exposition

1918 Philadelphia: Academy of the Fine Arts exhibition

1919 Philadelphia: Art Club of Philadelphia, Exhibition of Sculpture by R. Tait McKenzie

1920 London: Fine Arts Society, Exhibition of Bronze Statuettes and Reliefs by R. Tait McKenzie

1921 New York: Ferargil Galleries, Exhibition of Sculpture including Statues, Statuettes, Sketches, Portraits in Low Relief and Medals

1923 New York: National Sculpture Society exhibit

San Francisco: Gump's Art Gallery

1924 New York: National Sculpture Society, exhibit in the gardens of the Hispanic Building

New York: Grand Central Art Galleries, Exhibition of Sculpture including Statues, Statuettes, Sketches, Portraits in Low Relief and Medals by R. Tait McKenzie

Philadelphia: The Art Alliance, Sculpture in the Open Air: The Work of Living American Sculptors

Paris: Galleries Georges Petit, Exposition R. Tait McKenzie

1925 Boston: Gallery of Doll and Richards, Exhibition of Sculpture including Statues, Statuettes, Sketches, Portraits in Low Relief and Medals by R. Tait McKenzie

1926 Newport, Rhode Island: Art Association of Newport, annual exhibition

1927 Philadelphia: Art Alliance, Exhibition of the Working Models of the Scottish War Memorial by R. Tait McKenzie

New York: New York Academy of Medicine, The First Exhibition of Works in the Plastic and Graphic Arts by American Physicians

New York: Grand Central Art Galleries, Exhibition of Sculpture including Statues, Statuettes, Sketches and Recent Studies for Monuments by R. Tait McKenzie

London: Fine Arts Society, Exhibition of Sculpture by R. Tait McKenzie

1928 Toronto: Art Gallery of Toronto, Six exhibitions including the Canadian Society of Graphic Art, the Toronto Camera Club, Paul Manship, R. Tait McKenzie, Robert Holmes, Albrecht Dürer

New York: National Sculpture Society, Exhibition of American Sculpture

Philadelphia: Art Alliance, Sculpture in the Open Air

1929 New York and San Francisco: National Sculpture Society, Contemporary American Sculpture

London: Royal Academy of Arts

1930 London: Fine Arts Society, Exhibition of Sculpture by R. Tait McKenzie

1931 Philadelphia: Art Alliance, Exhibition of Medallions, Medals and Plaques including Portraits of Prominent Philadelphians by R. Tait McKenzie

1932 New York: M. Knoldler and Company, Boxing—an Exhibition of Paintings, Prints and Sculpture

Washington: National Sculpture Society, Washington Bicentennial Exhibition, Museum of History, Science and Art

Los Angeles: Olympic Competition and Art Exhibition, 10th Olympiad

1934 New York: Grand Central Art Galleries, The Athlete in Sculpture, an Exhibition by R. Tait McKenzie

1936 New York: Grand Central Art Galleries, Exhibition of Some Recent Works by R. Tait McKenzie

Philadelphia: Philadelphia Flower Show, R. Tait McKenzie's sculpture represented

Boston: Gallery of Doll and Richards, Exhibition of Sculpture by R. Tait McKenzie

Berlin: Halle VI des Ausstellungs, Geländes am Kaiserdamm, Competition and Exhibition of Art, 11th Olympiad

1938 San Francisco: American Medical Association Exhibition

London: Tate Gallery, A Century of Canadian Art

1940 Philadelphia: Philadelphia Art Alliance, University of Pennsylvania Bicentennial Celebration 1740-1940, Memorial Exhibition of Sculpture by R. Tait McKenzie

Index